IMAGES
of America

SMITHFIELD
Ham Capital of the World

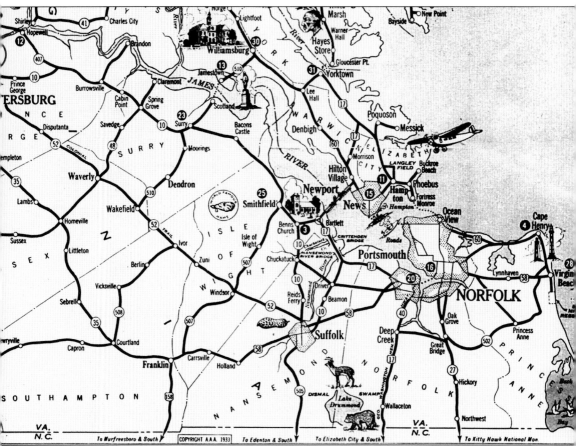

THIS IS HAM COUNTRY. Smithfield is located in Isle of Wight County, an area known as Hampton Roads or Tidewater, northwest of Norfolk and Virginia Beach. Although the first settlement was established in 1619, the county's history began in 1608 when Capt. John Smith explored the area south of his Jamestown colony, in search of food and trade with the Warascoyak Indians. If he were around today, he would find plenty of Smithfield ham, a specially cured country ham first commercially developed in the region in the 1770s. The town from which the ham gets its name was established in 1752 by Arthur Smith IV. A river port town, quaint Smithfield has thrived and is now known as the "Ham Capital of the World." This charming 1933 map shows the region and regional icons, including the home of "World Famous Hams." (IOW.)

IMAGES
of America

SMITHFIELD
Ham Capital of the World

Patrick Evans-Hylton

ARCADIA

Published by Arcadia Publishing
Charleston SC, Chicago IL, Portsmouth NH, San Francisco CA

Printed in Great Britain

Library of Congress Catalog Card Number: 2004112675

For all general information contact Arcadia Publishing at:
Telephone 843-853-2070
Fax 843-853-0044
E-mail sales@arcadiapublishing.com
For customer service and orders:
Toll-Free 1-888-313-2665

Visit us on the internet at http://www.arcadiapublishing.com

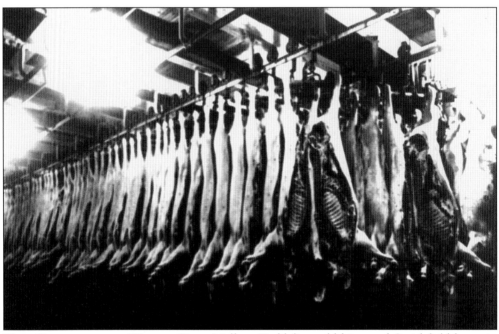

HAM CAPITAL OF THE WORLD. Since Mallory Todd first sold his cured Smithfield hams in the late 1770s, the town has been synonymous with the flavorful cut of pork. Here, a rod full of dressed, split hog carcasses await processing at Gwaltney and Company's new Plant 3, c. 1954. (IOW.)

CONTENTS

ACKNOWLEDGMENTS

Compiling information and photographs that chronicle the history of Isle of Wight County, the town of Smithfield, Virginia, and the Smithfield ham industry was no small task. It was only possible because of the assistance and expertise of many giving and gifted individuals. To everyone who lent their time, talent, and support in this effort, I thank you.

I would like to personally thank the following individuals who went above and beyond in their assistance and support: Susan Beck, Katie White, and Kathryn Korfonta of Arcadia Publishing; Dinah Everett, Diane Hayes, and Lori White of Isle of Wight County Museum; Gretchen Heal of *The Smithfield Times*; Betty Thomas; Dee Dee and Tommy Darden of Darden's Country Store; Cathy Kurchinski and Diane Spencer Wooley of the Smithfield & Isle of Wight Convention & Visitors Bureau; Joseph W. Luter III of Smithfield Foods; Larry Santure of Gwaltney of Smithfield; Thomas L. Evans of Smithfield Packing Company; Trey Gwaltney of Antiques Emporium; and Debbie Huss of the Genuine Smithfield Ham Shoppe.

Special thanks for moral support and encouragement are due to my friends and my family, especially Wayne.

On the cover: Thank you to Smithfield Foods for permission to reprint this photo of ham executive Peter D. Pruden dressed up in storekeeper garb in the *c.* 1930s restored country store, which is part of the Isle of Wight County Museum. The photo originally appeared on a *Smithfield Collection* catalog cover.

INTRODUCTION

The town of Smithfield and the county Isle of Wight are rich in heritage and tradition. Native Americans knew this area as Warascoyak (also spelled Warrosquoyacke, meaning "point of land") and enjoyed the abundant hunting in lush forests and fishing in the Blackwater, James, and Pagan Rivers.

In 1607, the British colonists sailed past the county's shores on the way to Jamestown. In 1608, Capt. John Smith and Native Americans traded beads for 30 bushels of corn near present-day Burwell's Bay.

The first permanent English settlement in Isle of Wight was established in 1619 at Lawnes Creek. Warascoyak was formed in 1634 as one of Virginia's eight original shires. Its name was changed three years later to Isle of Wight because many of the region's settlers came from Isle of Wight, England.

With the hubbub of shipping tobacco and other products back to Mother England, the first town in Isle of Wight was created in 1680 at the parting of the Pagan Creek, known as Pate's Field.

In 1752, Arthur Smith IV laid out a portion of his land in Pate's Field into street lots and petitioned the general assembly in Williamsburg to incorporate the town.

The county has seen good times and bad. Blood has been shed on her soil during fights with Native Americans, the Revolutionary War, and the Civil War.

Smithfield and Isle of Wight were poised on the Pagan River, a tributary to the James River, for exports of not only tobacco, but other, newer cash crops—peanuts and ham.

Peanuts became big business after the Civil War as an easy-to-grow crop providing a cheap source of protein. Pembroke Decatur (P.D.) Gwaltney Sr. became known as "the Peanut King" because of his large peanut cleaning plant and warehouse, which brought the area notoriety and riches.

But it was Gwaltney's son, P.D. Gwaltney Jr., who brought perhaps the most attention to the area with another Virginia product: hams. Through corporate savvy and marketing genius, Gwaltney took a time-honored Smithfield tradition and made it big business.

Smithfield has been famous for hams (created by a process learned from Native Americans) since the late 1700s when Bermuda-native Mallory Todd set up shop offering the product. The salty, cured taste of a Smithfield ham is immediately recognizable and highly sought after. It is said that Queen Victoria loved Smithfield ham so much that she had six sent over to England once a week during her reign.

The ham industry is alive and well under the leadership of Joseph W. Luter III and his company, Smithfield Foods, the largest hog producer and pork processor in the world. The company raises 12 million and processes 20 million hogs annually. Their collection includes such well-known brands as Smithfield Premium, Smithfield Lean Generation, Gwaltney, and more. Overall annual sales exceed $8 billion.

Smithfield is known for a quaint way of living, antique shops, 18th- and 19th-century architecture, and overall quality of life, but it is the salty, sweet, country-cured pork that gives the town the distinction of being Ham Capital U.S.A.

PHOTOGRAPH LEGEND

IOW: From the archives of the Isle of Wight County Museum.
CK: Photography by Cathy Kurchinski.
TLE: From the collection of Thomas L. Evans.
PEH: From the collection of Patrick Evans-Hylton.
All other photographs are individually credited.

One
ISLE OF WIGHT COUNTY

On December 29, 1608, Capt. John Smith and 28 other men sailed across the James River from their Jamestown settlement and met with members of the Warascoyak tribe. Thus began the written history of what is now Isle of Wight County.

A slender, slanting strip of land west of Norfolk and the Hampton Roads region of southeastern Virginia, Isle of Wight County, then known as Warascoyak, was one of the original eight shires established in the New World in 1634. The 1635 census shows a population of 532. The next year, the area was renamed Isle of Wight.

Later, parts of the county were removed to become part of Brunswick County (which later became part of Greensville County) and to form Southampton County.

Across Isle of Wight, communities sprung up, first around the water. Settlements were established at what are now Burwell's Bay, Mogart's Beach, and Day's Point. Later, the town of Smithfield was formed and was incorporated in 1752.

Other places in the county include Battery Park, Benn's Church, Camptown, Carrollton, Carrsville, Collosse, Comet, Four Square, Indika, Moonlight, Orbit, Rescue, Septa, Tyler's Beach, and Windsor.

Isle of Wight has been largely an agrarian county—there are still folks who make their living farming. Being on the James River, the region is also home to watermen who fish and oyster. Plenty of trees support a lumber industry, and the town of Smithfield is world famous for its cured hams.

It is a county with a past and a future.

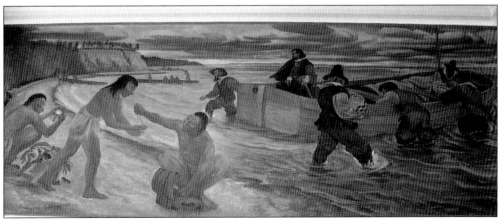

CAPT. JOHN SMITH TRADES WITH NATIVE AMERICANS. This mural, commissioned by the Fine Arts Public Buildings Administration Federal Works Agency in 1941, is displayed in the Smithfield Post Office. The work, by Massachusetts artist William Abbott Cheever, depicts Capt. John Smith purchasing 30 bushels of corn for the starving settlers in the Jamestown colony from Native Americans at Burwell's Bay along the James River in 1608. (PEH.)

NATIVE AMERICAN CURING METHODS.
The process of curing meat has been around for centuries; every culture develops techniques of curing food to prevent deterioration. The English had its own process but acquired new ones from the Native Americans. It is said colonists observed Native Americans smoke-curing venison; this method may have been attributed to tips from Spanish missionaries, who were in the area in the 1570s. The method was later applied to pork. (IOW.)

NECESSITY BEGETS INVENTION. Since there was no refrigeration in Colonial days, meats were first cured for storage rather than for flavor. But the combination of native razorback hog meat, curing spices, and smoking wood made hams a favorite; they were routinely shipped to epicures, from the king down, in Mother England. During the Revolutionary War, an aide of General Washington seized every Smithfield ham, believing they would strengthen American troops. (IOW.)

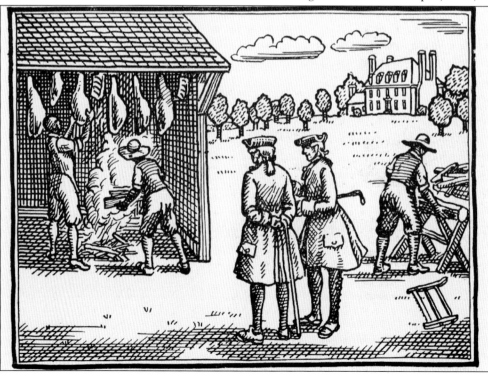

MOTHER CHURCH OF WARASCOYAK. This late 19th-century print shows the Old Brick Church, also known as the Mother Church of Warascoyak and called St. Luke's since 1828. Located just south of Smithfield, it was constructed in 1632, making it the oldest existing church of English foundation in this country and the nation's only surviving original Gothic building. It has been the church to many of the region's most influential figures. (IOW.)

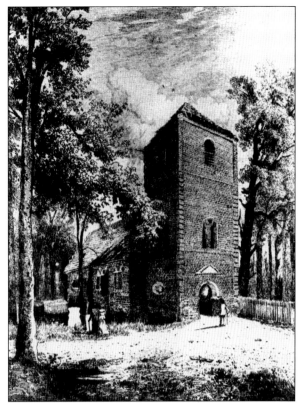

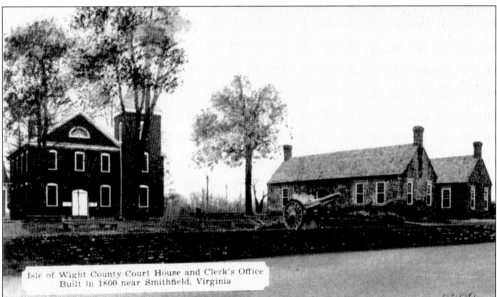

Isle of Wight County Court House and Clerk's Office
Built in 1800 near Smithfield, Virginia

ISLE OF WIGHT COUNTY COURTHOUSE AND CLERK'S OFFICE. This *c.* 1937 postcard shows the courthouse complex in the community of Isle of Wight, located in the center part of the county. The courthouse complex opened in 1800 and replaced the original courthouse in Smithfield. The area is still the county seat today. Located next door is the Francis Boykin Tavern, the restored *c.* 1780 home of the original landowner. (IOW.)

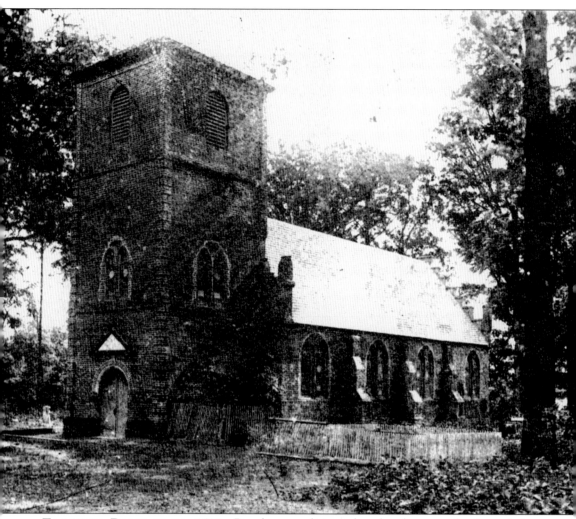

TRADITION DATES IT TO 1632. Based on tradition, the church vestry book, and the architectural style, St. Luke's has been dated to 1632. During an 1887 renovation, three bricks with the date "1632" were found, one of which is on display. A parish organization existed in Warascoyak as early as 1629, five years before the establishment of the original eight Virginia colony shires. By 1634, there were 522 persons in the parish. But over time, the church was used, abandoned, reused, and restored. It was in extreme disrepair in 1953 when Historic St. Luke's Restoration Incorporated was established to return the building to its original grace and beauty. Visitors today can get a glimpse of Medieval English architecture by studying St. Luke's Gothic buttresses, stepped gables, brick-traceried windows, and the timber-trussed roof structure. Historic St. Luke's Church is open for tours daily, except Monday, from February through December. There is also a quaint gift shop on the grounds. Proceeds go for the upkeep of the building. This early 20th-century photo shows the church in a declining state. (IOW.)

St. Luke's Altar and Pews.
This October 1933 photograph, taken just before the wedding of Nancy Warner and Thomas Dashiell, details the beautiful interior of the Old Brick Church. The first interior was temporary and was finished later in a Jacobean style. One interior furnishing is an exceptionally rare *c.* 1630 English chamber organ, which features Old Testament scenes painted on the panel doors. (IOW.)

The Old Brick Church Today.
Originally an Anglican church, St. Luke's became an Episcopal church after the American Revolution. It is the oldest surviving Protestant church in America. Called the Old Brick Church as early as 1727, it became known as St. Luke's when it became an Episcopal church. Unfortunately, the original vestry book was destroyed by mold after being buried during the Revolutionary War. (CK.)

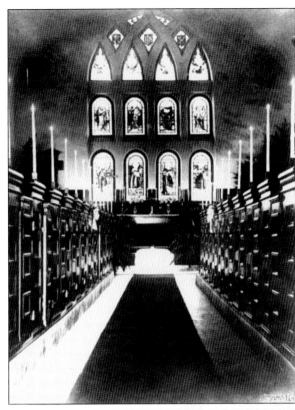

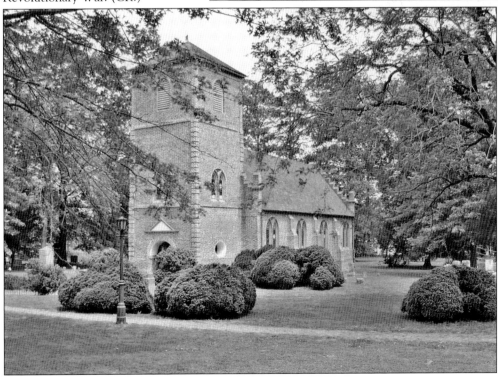

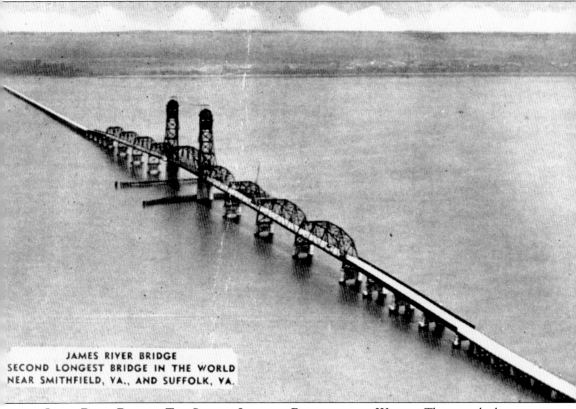

JAMES RIVER BRIDGE
SECOND LONGEST BRIDGE IN THE WORLD
NEAR SMITHFIELD, VA., AND SUFFOLK, VA.

JAMES RIVER BRIDGE: THE SECOND LONGEST BRIDGE IN THE WORLD. That was the boast on the front of this mid-20th century postcard. When the nearly five-mile, $5.2-million span opened November 17, 1928, it connected Newport News with Isle of Wight County. It marked a new day of being connected for the area, which, until then, was linked to the outside world by infrequent steamboat service and mostly unpaved roads. The area also benefited from the rerouting of U.S. 17 through the county; in 1932, U.S. 17 was routed away from Norfolk—in Portsmouth, it turned west to use the James River Bridge. The structure was built and administered by the James River Bridge Corporation and was taken over by the state during World War II. The original bridge was replaced by a wider span in the 1980s. It was a toll facility until 1975. A half mile of the original bridge remains and is used as a fishing pier on the Newport News side of the river. (IOW.)

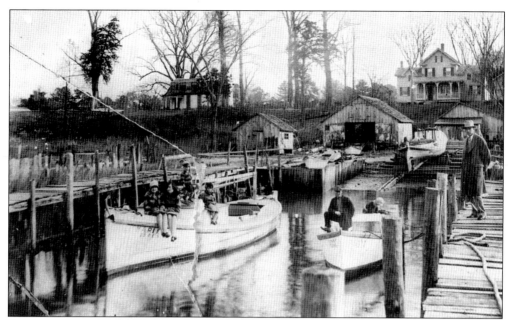

BOATS IN BATTERY PARK. The David Lowe III family is seen in this early 20th-century photo of their home and dock at Battery Park. During the Civil War, a large battery was placed near the home of John R. Todd, son of ham pioneer Mallory Todd. The area, just east of Smithfield, became known as Battery Park. A company chartered in 1890 to develop the land sold the first lot for $100 to Mrs. Hughella V. Lowe. (IOW.)

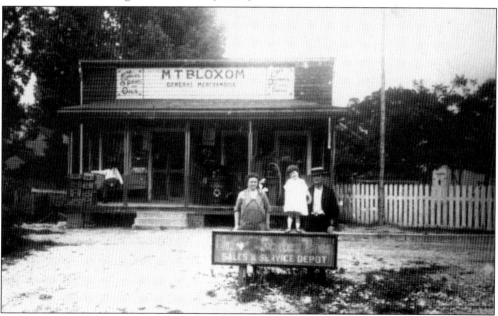

GET IT ALL AT THE GENERAL STORE. Like many rural areas, Isle of Wight County depended on general stores until the mid-20th century to supply residents with everything from dresses and dolls to lard, sugar, farm tools, and fertilizer. This c. 1930 photo shows M.J. Bloxom's store near Battery Park. Uniquely, in this region, many stores sold country hams the owners cured themselves, which helped build today's ham industry. (IOW.)

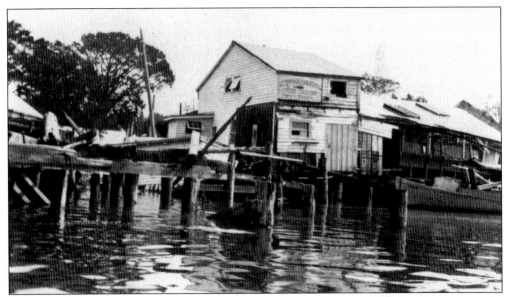

BATTERY PARK FISH AND OYSTER COMPANY. This concern started in 1913 in Battery Park by O.A. Bloxom to "can, ship, buy, and sell, by wholesale or retail or both, oysters, vegetables, fruit and fish of every kind and description." The business was disrupted, as seen in this photo, by the August 1933 Chesapeake-Potomac Hurricane that blew through the region. Many folks in the area have traditionally made their living on the water. (IOW.)

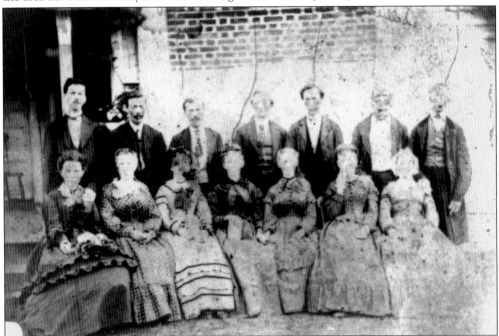

CARRSVILLE COUPLES. This c. 1860 photograph shows seven Carrsville couples, all unidentified. A small community in western Isle of Wight County, Carrsville was named for postmaster Nathan Carr, who held the title in 1836, about the same time the first railroad, the Portsmouth and Roanoke, went through town. The name Carrsville first appeared in an 1846 tax book. (IOW.)

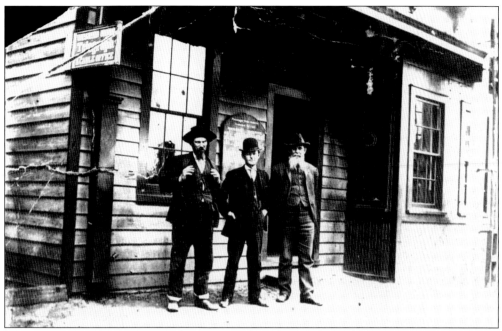

CARRSVILLE RAILWAY DEPOT. The Portsmouth and Roanoke Railroad later became known as the Seaboard Air Line; the company's station was on the north side of the track in Carrsville. This early 20th-century photo shows the depot and identifies the men as, from left, Joseph Johnson, Jack Duke, and Ben White. Several rail lines, such as this one, would cross Isle of Wight but, interestingly, would bypass Smithfield. (IOW.)

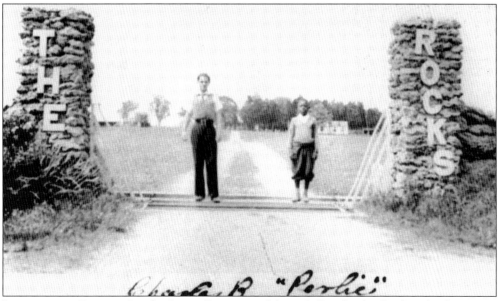

LIFE AT THE ROCKS. On the James River near Mogart's Beach, the Rocks, also known as Bennett's Plantation and Rockingham, is the 1621 settlement of London merchant Edward Bennett. Along with the nearby Basse's Choice settlement of Capt. Nathaniel Basse, most inhabitants were killed at the Good Friday Indian Massacre in 1622. In this *c.* 1930 photo, these boys pose in front of the entrance to the Rocks, now a private residence. (IOW.)

17

SHIPS AHOY. From the beginning, the Rocks was a working farm. Almost immediately after settlement in 1621, a wharf and a tobacco warehouse were constructed. In this early 1900s photo, potatoes were being loaded for export. Next to the Rocks is Fort Boykin, originally named the Castle, constructed in 1623 to protect the colonists from Native Americans and Spaniards. Now a park, the fort has been involved in every major campaign fought on American soil. (IOW.)

COME AND GET IT. Here is a July 1922 outing at Mogart's Beach, a sandy stretch along the James River. A hotel welcomed guests, one of whom was Roy Conklin, who remembers, "Day's Point Hotel under Mr. and Mrs. Mogart, was a small country hotel, but . . . it was clean and attractive. . . . The table . . . groaned with the good things to eat. Mogart provided lavishly from the river and his garden." (IOW.)

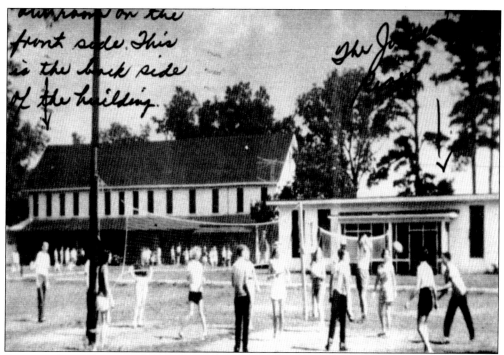

SUMMER ALONG THE JAMES. The Mogart's Beach resort changed hands and grew; a large bath house was added along with dining and dancing facilities. In 1941, the property was sold to the Future Farmers of America–Future Homemakers of America. The hotel was raised to create a camp for the students, as shown in this vintage postcard, and is still used. Few public amenities are available at the beach, however. (IOW.)

SURF AND SUN. The Dashiell family enjoys an August 1926 outing at Mogart's Beach. Here H.G. Dashiell Jr. is with 10-month-old R.A. Edwards Jr. The Dashiell family members are longtime Isle of Wight County residents. Harry Dashiell Sr.'s wife, Segar Cofer Dashiell, wrote a history column for local newspapers for years and wrote an extensive pictorial history book of the community in 1977. (IOW.)

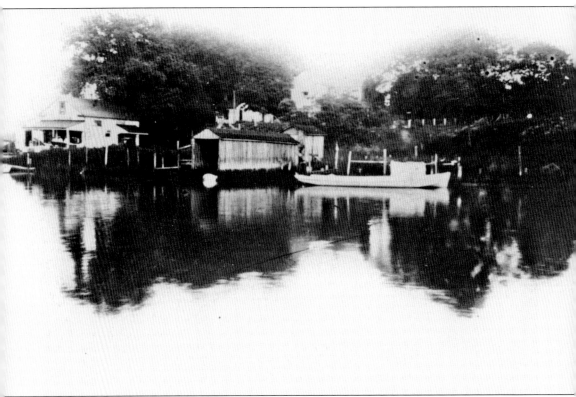

TO THE RESCUE. Rescue is a small community along the Jones Creek, which separates Rescue from Battery Park, just east of Smithfield. This *c.* 1945 photo shows Milby's Store, O.S. King's Boathouse, the oyster inspection boat *Sam Slick*, and the homes of Ralph King and Willis Milby. Tradition has it that sometime around 1889 (the year the first post office opened in town), a man rode into the village on a mud-stained mule, and a bystander yelled out, "Hurrah, we've been rescued!" More than likely, the name was a result of a rescue attempt in the James River. Jones Creek feeds into the Pagan River, a tributary of the James River. Jones Creek winds southward to St. Luke's Church. Close to Rescue is the community of Carrollton, named for an early 19th-century merchant, Samuel Carroll. (IOW.)

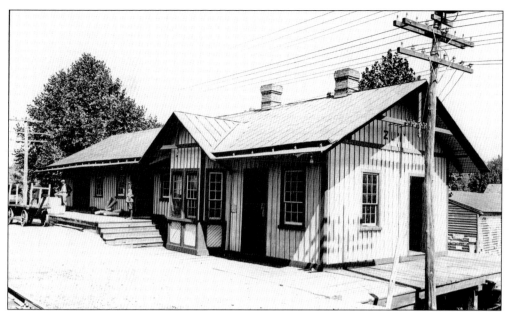

NEXT STOP: ZUNI. This is the Norfolk and Western Station in the small community of Zuni. The rail line ran north-by-northwest across the county, which is roughly the path the current Route 460 follows. Communities sprung up along the route, which was started in 1853 and completed in 1858. Tradition says the railroad president's wife, Otelia Butler of Smithfield, named stations along the way—Windsor, Waverly, Ivor, Wakefield—based on places and names in Walter Scott novels. (IOW.)

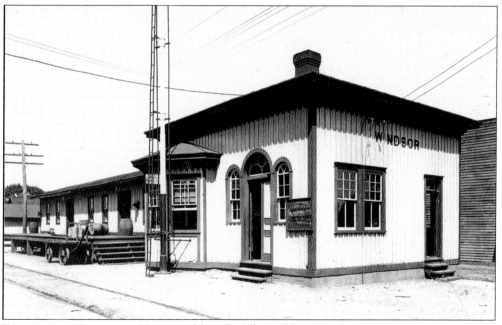

WINDSOR: A RAILROAD TOWN. Although folks had been settling in Corrowaugh in south-central Isle of Wight County since 1681, it was the railroad, which came through in the 1850s, that gave birth and name to Windsor. Today, the community is thriving, but the Norfolk and Western Station shown in this mid-20th century photo is no longer standing. (IOW.)

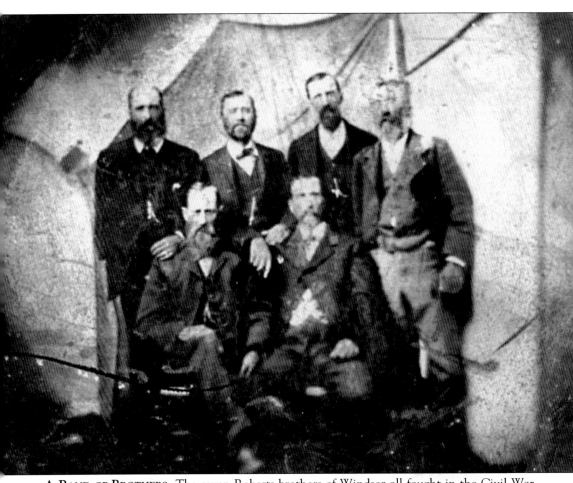

A BAND OF BROTHERS. The seven Roberts brothers of Windsor all fought in the Civil War, and, improbably, all returned home. In this vintage photo, the six pictured are, from left to right, the following: (front row) Mills W. and Steven Wyatt Roberts; (back row) John Walter, Benjamin Claudius, Frances Columbus, and Sylvester James Roberts. Nathaniel Cornelius Roberts is not pictured. One brother joined a Portsmouth regiment; the rest signed up with the Isle of Wight Rifle Grays just 10 days after the firing on Fort Sumter. One became an officer. One lost his right arm. The brothers fought at the Seven Days Battles, Second Bull Run, Antietam, the Wilderness Campaign, the Battle of Cold Harbor, and the Siege of Petersburg. Some were wounded, some were captured, but they all returned to combat. Three were at Appomattox with Gen. Robert E. Lee when he surrendered. When they came home, they became local businessmen, farmers, and tradesmen. One became a member of town council. Others became involved with local churches and civic groups. Three died before the turn of the 20th century. Benjamin lived the longest, until 1926. (IOW.)

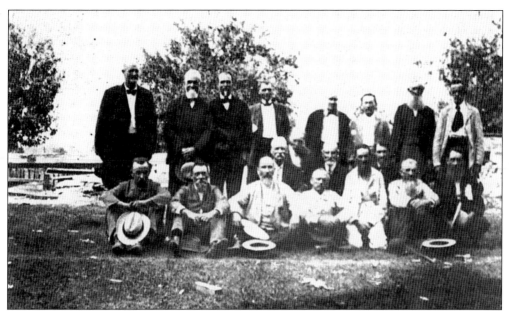

THE CIVIL WAR COMES TO ISLE OF WIGHT. This early 20th-century photo shows area Civil War veterans at a reunion. Although these men went off to war, war also came to Smithfield; engagements January 31 through February 1, 1864, during the Battle of Smithfield, resulted in the destruction of the Union gunboat USS *Smith-Briggs*. Fort Boykin, on the James River, saw action in 1862, and St. Luke's Church was a Confederate campground. (IOW.)

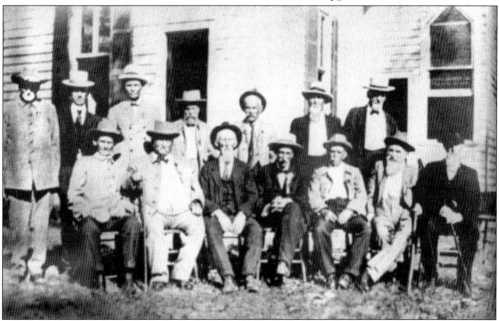

REMEMBERING THE PAST. Confederate veterans gather for a reunion *c.* 1930 at Beaver Dam Baptist Church. They are, from left to right: (front row) Ely Daughtrey, Sgt. Jacob J. Bradshaw, David Lisbon Butler, John Bradshaw, and Jack Edwards; (back row) Henry Harrison Duke, two unidentified people, Elias Whitley, unidentified, George W. Scott, and Corp. J.P. Rhodes. The church, near Carrsville, was where many of the veterans went to enlist as young men. (IOW.)

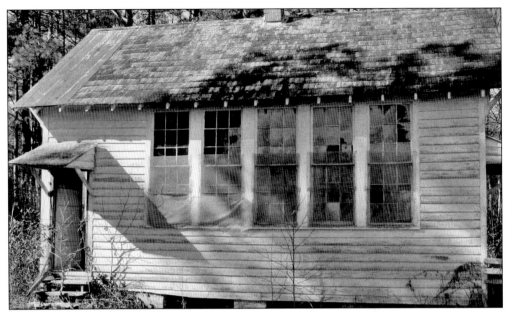

SCHOOL DAYS. This was one of about two dozen one- and two-room schoolhouses that dotted Isle of Wight until the mid-20th century, when replaced by larger schools. It was the Christian Home School, an elementary school for African Americans, from the early 1920s to the late 1940s. The school is being moved to downtown Smithfield and renovated to house a museum on the county's early education, with a focus on schools for African-American children. (CK.)

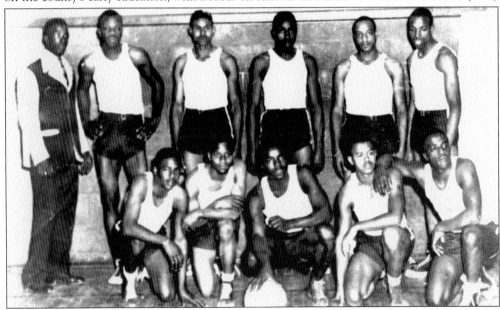

ISLE OF WIGHT TRAINING SCHOOL. In 1928, this became the first comprehensive school for African Americans, housing grades 1 through 12. It became Westside High in 1960 and, after integration, Smithfield Elementary in 1969. Now, in a new building, it is Smithfield Middle School. Shown is the 1938 Isle of Wight Training School basketball team, including (back row, far right) Charles Henry Gray, who became a ham executive, and (front row, far left) James Chapman, who became Smithfield's first African-American mayor. (IOW.)

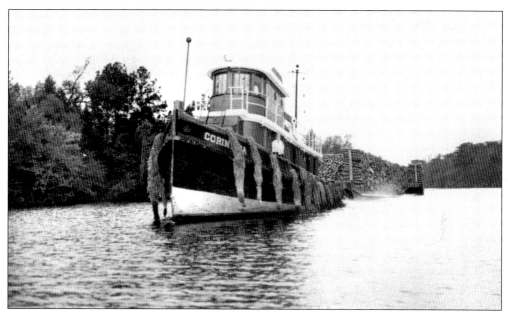

RIVER BARGE *CORINTHIA*. This is a log-loaded barge on the Blackwater River, *c.* 1950, heading for the Camp Manufacturing Company near Franklin. The concern, founded by Paul D. Camp and his brothers James L. and Robert J. in 1887, logged trees in the western part of Isle of Wight and 100 miles around. In 1956, the company became Union Camp and is today part of International Paper, a Fortune 500 company. (IOW.)

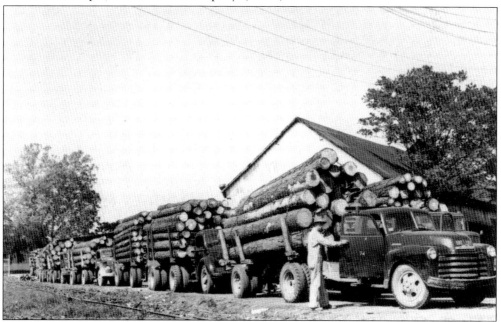

LOGS TO UNLOAD. Logging trucks wait to unload at Camp Manufacturing in this *c.* 1945 photo. Although associated with the town of Franklin, the paper concern is located across the Blackwater River in Isle of Wight County. A saw mill was established here in 1856 and operated until it was purchased by the Camp brothers in 1887. Trucks, tugs, and trains were used to haul lumber from a 100-mile radius around the mill. (IOW.)

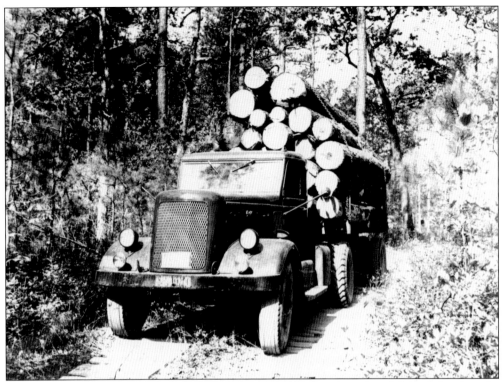

FROM PINE TO PAPER. A logging truck comes out of the woods with a full load, heading for Camp Manufacturing, in this *c.* 1945 photo. Today, the Franklin Mill produces approximately 2,100 tons of a variety of bleached virgin and recycled content "communication papers" daily. Papers used in copiers and laser and inkjet printers; uncoated offset presses; and coated board for greeting cards, cosmetic cartons, book covers, menus, and other products are produced here. (IOW.)

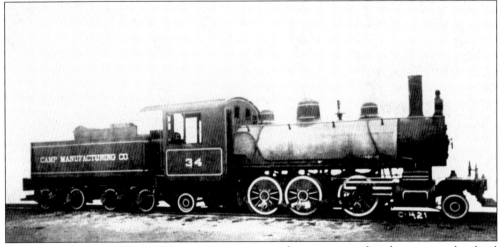

CHUGGING ALONG. This 1915 locomotive was part of a company railroad system used to haul logs to the Camp sawmill. Part of the line went into the Great Dismal Swamp in nearby Suffolk, which became a national wildlife refuge in 1974 when Union Camp donated 49,100 acres of forested wetlands to the Nature Conservancy. (IOW.)

Two

TOWN OF SMITHFIELD

Visited by colonists since 1608, it was not until 1619 that Capt. Christopher Lawne and Sir Richard Worsley made the first English settlement here, called Isle of Wight Plantation, in honor of Sir Richard's home off the coast of Britain. Other settlements followed: Bennett's Plantation in 1621 and Basse's Choice in 1623.

One community began to thrive, according to the 1884 writings of Smithfield's mayor of 1863–1866, Dr. John Robinson Purdie: "A warehouse for the inspection of tobacco was established at or near it [the main fork of the Pagan River] in 1633. The county seat of justice had been located there . . . and merchants, engaged chiefly in the shipment of agricultural produce . . . at least in 1730 . . . prove conclusively that this place had been a center of trade and commerce many years before the incorporation of the town."

The settlement became the incorporated town of Smithfield in 1752 when the general assembly authorized Arthur Smith IV to separate by survey a part of his nearby land into streets and lots.

Smithfield, about 25 miles from Norfolk, saw action in the American Revolution (Benedict Arnold occupied it in 1781), and the Civil War (an 1864 battle took place on Main Street).

Tobacco gave way to peanuts as the local industry, which came to an abrupt end following the Great Smithfield Fire of 1921, which wiped out the warehouse district. Today, the town's pride is in Smithfield ham, a business that began before 1800 and gained world notoriety in the early 20th century.

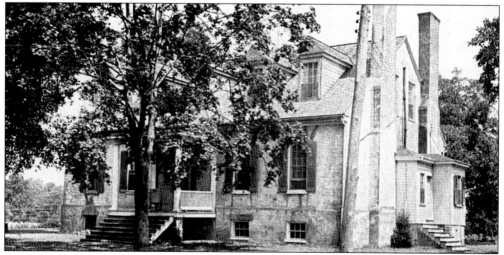

WINDSOR CASTLE. This Colonial home was thought to have been built around 1750 by Arthur Smith IV, founder of Smithfield, on land owned by the first Arthur Smith (said to have been related to Capt. John Smith), who in 1637 patented 1,450 acres; some of these were used to create the town, and 186 acres remain. In more than 300 years, the land has been owned by three families: the Smiths, the Jordans, and the Johnson-Betts. (IOW.)

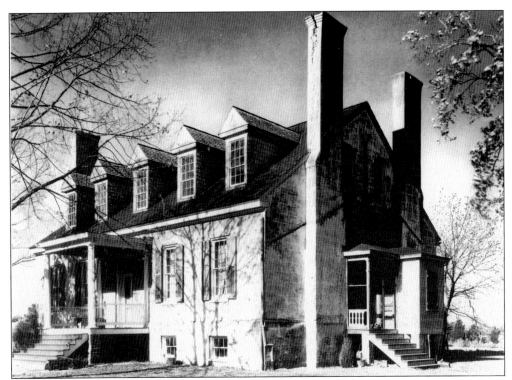

OVERLOOKING THE PAGAN RIVER. Windsor Castle, a private residence, sits on a knoll overlooking a branch of the Pagan River and is part of a larger agricultural complex that includes several 18th- and 19th-century outbuildings. The home was remodeled about 1840 to add Greek revival accents popular in the day. The property is being considered for development of homes, apartments, and shops, leaving 40 acres to be preserved and maintained. (IOW.)

THE OLD COURTHOUSE OF 1750. This building was the Isle of Wight courthouse until a complex was built in the center of the county in 1800. Located on Main Street in Smithfield, it was modeled after the capitol building in Colonial Williamsburg. A private residence for years, the restored building is now owned and operated by the Association for the Preservation of Virginia Antiquities. It is open to the public, with free admission. (CK.)

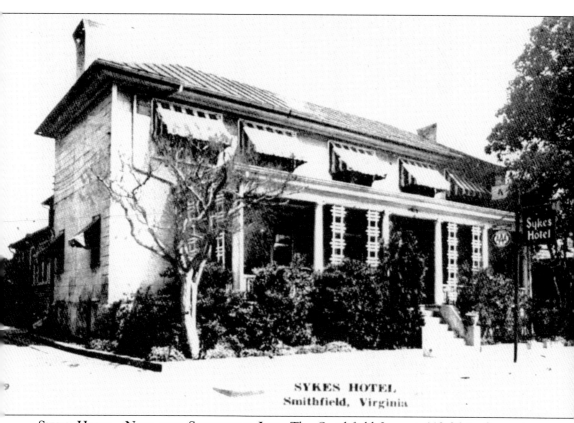

SYKES HOTEL.
Smithfield, Virginia

SYKES HOTEL, NOW THE SMITHFIELD INN. The Smithfield Inn, at 112 Main Street in downtown Smithfield, was known for more than 40 years as the Sykes Inn, as shown in this *c.* 1930 postcard. Built in 1752 for Henry Woodley, the inn served the main stagecoach route that passed through from Norfolk to Richmond. In 1756, it was sold to William Rand, who applied for a license to operate an inn and tavern in 1759. There have been several owners, including Mr. and Mrs. Daniel Sykes, who purchased and renovated it in 1922. The Sykes Inn was known for its home-cooked food, leisurely formality, and refined attendance, and was frequented by travel writer Duncan Hines. The Sykeses retired in 1968, and there was a succession of owners. Today the beautiful inn is owned by Joseph W. Luter III and Smithfield Foods. It features large, charming rooms and a restaurant serving upscale Southern regional cuisine. From notes in his diary, there is evidence George Washington stayed here in 1768. (IOW.)

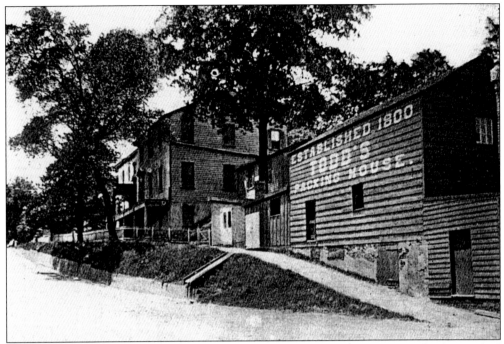

THE START OF A LEGACY. Although meats have been cured for centuries and colonists had been crafting country hams almost since they arrived in the New World, it was Mallory Todd who began selling and shipping hams from here in 1779, starting the heritage of Smithfield hams. The 1786 Todd packinghouse, which stood until the 1950s, is shown in this c. 1930 postcard. (IOW.)

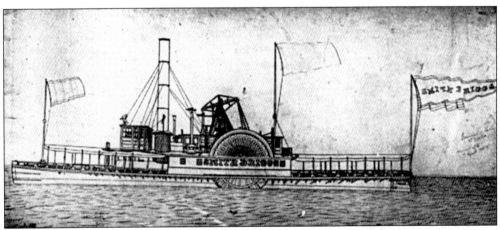

THE YANKEES ARE COMING. This c. 1930 print shows the paddlewheel ship *Smith-Briggs*, a Yankee gunboat that unloaded Union soldiers in Smithfield on January 31, 1864, leading to a small skirmish with Confederate troops that lasted into the next day and resulted in the burning and sinking of the ship. Though minor, the Battle of Smithfield was dramatic and included cannons being fired down the middle of Main Street. (IOW.)

GOLDEN EAGLE. A gilded carved wood eagle, wrenched from the pilot house of the Yankee gunboat *Smith-Briggs* as it sank, was the trophy gathered by Confederate captain Joseph Chapman Norsworthy, shown in this photo, following the 1864 Battle of Smithfield. Today, the golden eagle is on display at the Isle of Wight County Museum. The ship was set ablaze and blown to pieces when the flames hit the ammunition on board. (IOW.)

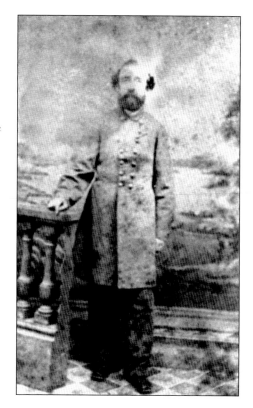

P.D. GWALTNEY SR., THE PEANUT KING. This photo of P.D. Gwaltney Sr. (1836–1915) is from the *Land of the Peanut* book published in 1904 by the Gwaltney-Bunkley Peanut Company for the Louisiana Purchase Exposition. Although the name Gwaltney is synonymous with ham, this Smithfield resident was known as the Peanut King around the turn of the 20th century because of his involvement in peanut processing. (IOW.)

GWALTNEY FAMILY GATHERING, 1914. This exceptional photo shows the P.D. Gwaltney Sr. family at P.D. Gwaltney Jr.'s home at 304 Church Street in Smithfield. The photo includes (back row, left) P.D. Gwaltney Jr., (seated) P.D. Gwaltney Sr., and (back row, right) Mrs. Estelle Darden Gwaltney. The Gwaltney children, front row from left to right, are: Chester, Howard, Julius, Lucy, and P.D. III. The family name had been associated with hams since the 1870s. P.D. Jr. managed the family store and expanded the meat packing business. By 1929, it had become P.D. Gwaltney Jr. and Company and, later, Gwaltney and Company. It was incorporated and reorganized, but it remained a family business with P.D. Jr. as president and chairman, Howard as vice president, P.D. III as secretary-treasurer, and Julius as assistant treasurer. P.D. Jr. died in 1936, but the company remained in family control until late in the 20th century. The Gwaltney House, still owned by members of the family, is a stunning example of Queen Anne architecture. It was added in 1999 to the National Register of Historic Places. (IOW.)

THE P.D. GWALTNEY JR. HOUSE TODAY. The Gwaltney House remains an impressive structure and symbol of the power and influence of the Gwaltney family in town; this influence is also evident in this excerpt from a 1923 article in *The Smithfield Times*: "Mr. Gwaltney would be a leading light in any community. He is a born builder, the type of man who helps to pull a city from the ruts and place it on the high road to prosperity." (CK.)

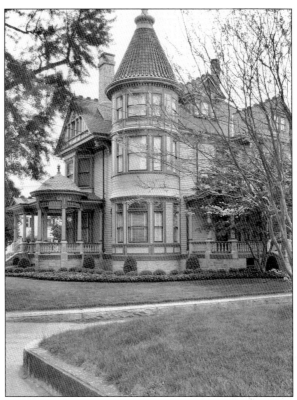

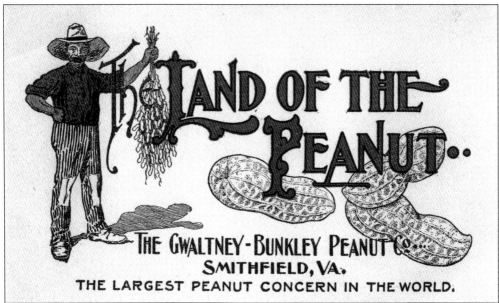

LAND OF THE PEANUT. Before Smithfield was known prominently for hams, the town was called the Land of the Peanut, and, until a devastating fire in 1921 wiped out the industry, it even outshined nearby Suffolk as Peanut Capital. This 1904 book touted Smithfield peanuts. It states that the Gwaltney-Bunkley Peanut Company "stands to-day the largest peanut company in the world." (IOW.)

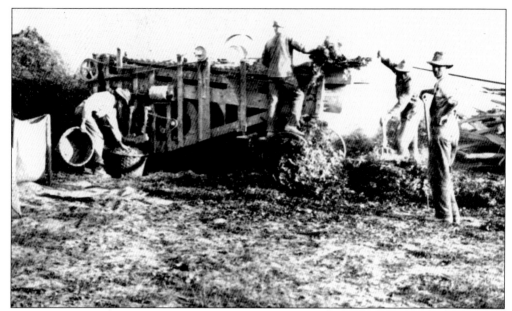

GLORIOUS GOOBERS. This *c.* 1950 photo shows the operation of a wooden peanut-picking machine on Holloway Farm near Benn's Church. After the Civil War, peanuts, a portable pack of protein, became a big cash crop. One peanut farmer was P.D. Gwaltney Sr., who cultivated goobers in Surry County and moved to Smithfield in 1870 to begin cleaning/sorting/processing other farmers' nuts. His company grew and, in 1911, became part of the American Peanut Corporation. (IOW.)

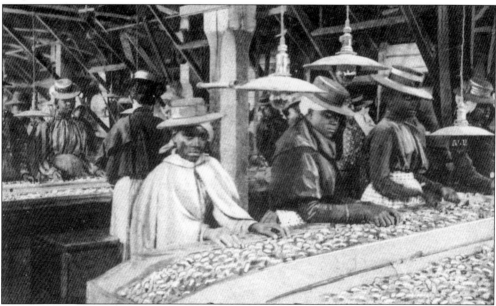

SORTING PEANUTS. Women in straw hats and bandanas sort peanuts *c.* 1901 in the Gwaltney-Bunkley Peanut Factory. In 1880, P.D. Sr. built the first peanut factory on Commerce Street (on the Pagan River) in Smithfield and put in machinery that was considered a marvel for cleaning and grading peanuts, although some work was still done by hand. In failing health, P.D. Sr., then 78, retired from the business. (IOW.)

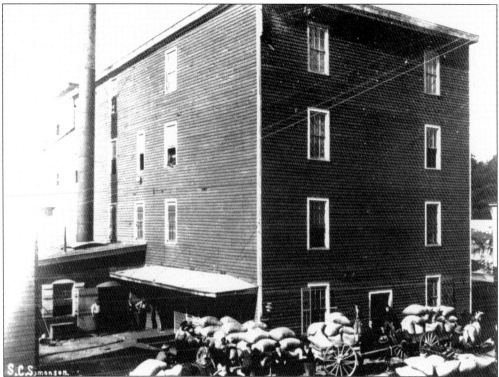

THE GWALTNEY-BUNKLEY PEANUT FACTORY. These *c.* 1901 photos are from the 1904 *Land of the Peanut* booklet. The first shows the Gwaltney-Bunkley Peanut Factory No. 1, with P.D. Gwaltney Jr. standing in the doorway and director F.R. Berryman (Gwaltney's son-in-law) in the lower foreground, leaning on the wagon. The second photo shows the Pagan River waterfront, at the foot of Wharf Hill, along Commerce Street, and the peanut warehouses that dotted the landscape. P.D. Sr. was involved in several businesses, including Gwaltney and Delk (1870), P.D. Gwaltney and Company (1880), P.D. Gwaltney and Sons (1882), Smithfield Telephone Company (1886), and Gwaltney-Bunkley Peanut Company (1891); most of these were general merchandising or peanut processing. In 1911, Gwaltney-Bunkley sold out to American Peanut Corporation. The buildings in these photos were destroyed in the Great Smithfield Fire of 1921. (IOW.)

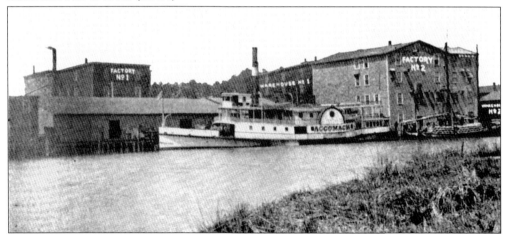

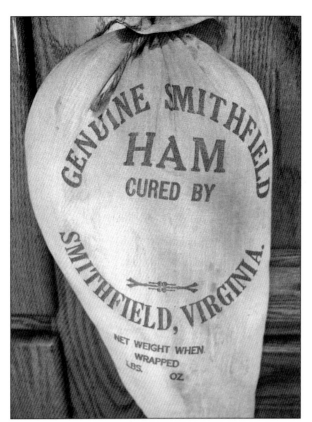

SACK IT UP, ALL TAKE IT. In 1882, P.D. Sr. and his son formed a partnership to run a retail and wholesale business, which P.D. Jr. managed. One of the offerings was country-cured ham. This bag, from the collection of Trey Gwaltney of Antiques Emporium in Smithfield, is an early swine sack from P.D. Jr.'s original store. P.D. Jr.'s marketing genius made Smithfield ham a household phrase. (PEH.)

HAMMING IT UP. This mid-20th century postcard promotes Smithfield's prominence as Ham Capital of the World. It reads, "The food here is wonderful . . . having a swill time . . . and the climate seems to agree with me . . . Greetings from Smithfield, Va." Folks still flock to this Tidewater town for the food and hospitality. (IOW.)

THE FOOD HERE IS WONDERFUL

HAVING A SWILL TIME

AND THE CLIMATE SEEMS TO AGREE WITH ME

241B

Greetings from SMITHFIELD, VA.

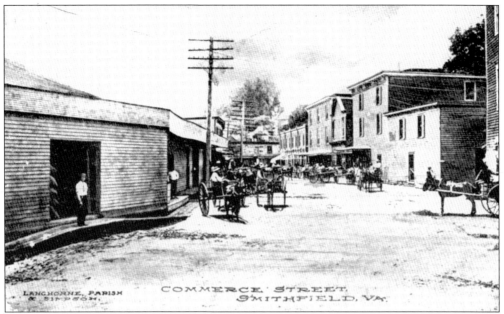

LANGHORNE, PARISH & SIMPSON.

COMMERCE STREET
SMITHFIELD, VA.

GLORY DAYS. The above postcard (postmarked 1913) shows busy Commerce Street (also known as the Wharf) along the Pagan River. From the early days of the 18th century, Smithfield was largely a shipping port that carried on a brisk trade with Great Britain, the West Indies, and ports of the Eastern seaboard. A public landing was built on the Pagan River as early as 1747, and a footpath leading to the wharf became Commerce Street. In 1779, Mallory Todd began shipping Smithfield hams from here, and other businesses developed. Steamships, hauling both freight and folks, linked Smithfield to the world. After the Great Fire of August 1921, more than half of Commerce Street was reduced to ashes and rubble; it never recovered. In recent years, luxury condominiums and a new Smithfield Foods headquarters have been built here. The card below is of Main Street from the same time. (IOW.)

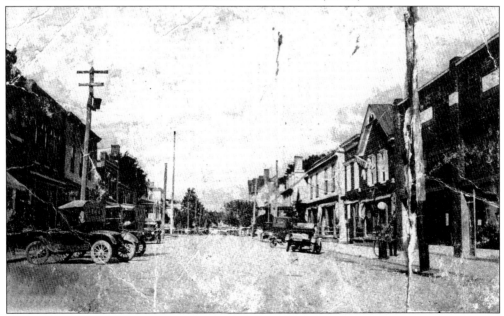

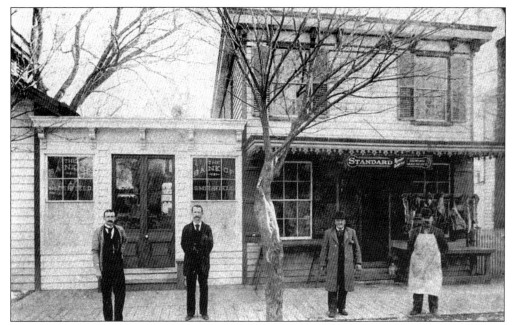

BANKING AND BUTCHERING. The small building on the left of this c. 1900 photo of Main Street is the Bank of Smithfield, which burned in 1912. To the right is E.W. Wilson's store; notice the sides of meat hanging outside. Standing on plank sidewalks, from left to right, are bank teller John I. Cofer Sr., bank cashier A.S. Barrett, town constable J.D. Clarke, and butcher/grocer E.W. Wilson. (IOW.)

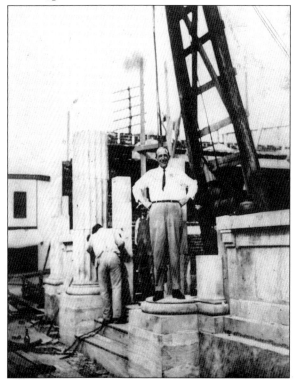

BANK OF SMITHFIELD. Chartered in 1891, many prominent citizens, including P.D. Gwaltney Jr., sat as a director of Bank of Smithfield. The original bank building burned in 1912, and a new one, as seen in this photo (with executive officer John I. Cofer Sr. standing on an unfinished column), was constructed at the corner of Main and Church Streets. The building today houses the Isle of Wight County Museum. (IOW.)

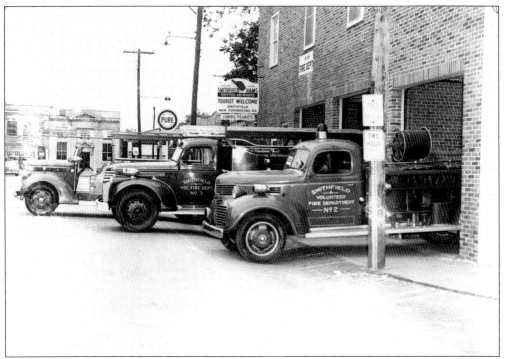

WHERE'S THE FIRE? The Smithfield Fire Department, c. 1950, is shown here at its Church Street location. Notice the Bank of Smithfield (now the Isle of Wight County Museum) down the street and the sign advertising Smithfield hams and peanuts. The Pure station is today the chamber of commerce offices. The fire building, constructed in 1939, is now used by the engineering department of Smithfield Foods; the fire station moved to the municipal complex on Institute Street. (IOW.)

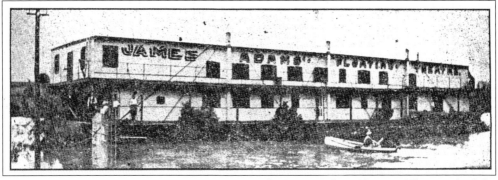

THE ORIGINAL SHOWBOAT. From 1914 to 1941, the James Adams Floating Theatre plied the waters of coastal Virginia, Maryland, and North Carolina. The barge featured an 850-seat auditorium for viewing a variety of performances. It cast anchor in one town for a week or so and moved on. Smithfield was a frequent stop. After a 1925 visit, Edna Ferber wrote the musical *Showboat*, which was later made into a movie, about her experiences. (IOW.)

James Adams

FLOATING THEATRE

ADMIT ONE

Parquette

Reserved Seat
Coupon

Sec.

Row

No.

QUITE A SHOW. A ticket stub from a showboat performance, c. 1920, is part of the exhibit at Isle of Wight County Museum, along with a scale model of the barge. Folks in Smithfield loved the visiting floating theater. A 1936 clipping from *The Smithfield Times* reads, "The Times takes this opportunity to again welcome The Show Boat . . . and cordially extends an invitation on behalf of citizens of this section to return next year." (IOW.)

SLOW BOAT TO SMITHFIELD. Steamboats had been ferrying passengers and packages since 1819, but when Virginia began to build paved highways in the 1920s (including the James River Bridge, which opened in 1928), automobiles and trucks lessened the necessity for boats. Smithfield's peanut industry was wiped out by fire in 1921 and moved to railroad-accessible Suffolk. By the early 20th century, regular schedule boats, like the one in this c. 1900 photo, had stopped making port in town. (IOW.)

40

NOT ANOTHER HOME DÉCOR CATALOGUE. The mail boat docks at the foot of Wharf Hill in this c. 1915 photo. The importance of the Pagan River in the development of Smithfield cannot be emphasized enough; it connected the town with the world. Commerce sprung from the river (including exportation of Smithfield hams), and it was a watery highway for people, imports and exports, and mail. (IOW.)

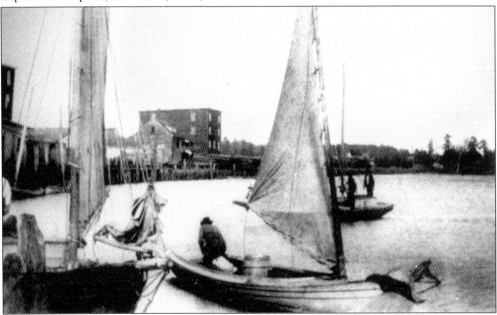

BOATS ON THE PAGAN. Until paved highways and the James River Bridge came along early in the 20th century and because the town never had railroad access, the water was Smithfield's lifeblood; at one point, two steamers ran daily to Newport News and Norfolk. This early 1900s photo shows sailboats on the Pagan River (formerly Pagan Creek, named as early as 1637, probably in reference to the Native Americans who lived there) and warehouses along Commerce Street. (IOW.)

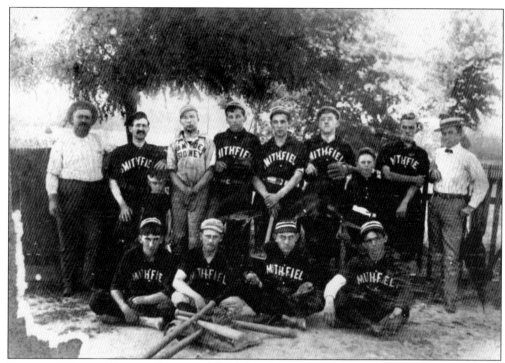

BATTER, BATTER, SWING BATTER. All of America loved baseball, and Smithfield was no exception. This *c.* 1910 photo shows the Smithfield team, ready for play in a league with other small towns in the region. The sport was an entertainment diversion in a time that lacked movies and television. (IOW.)

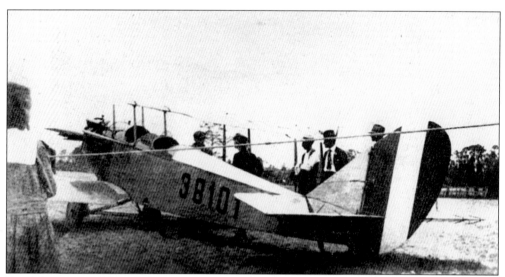

FLY ME TO THE MOON. Aviation was relatively new in May 1918, when this plane from Langley Field in Hampton crossed the James River and landed in Luster Thomas's cow pasture. The whole town turned out to witness the arrival of the air age; it is reported that one woman fainted at the sight. A rough landing snapped the propeller, and it was not until the next day that a replacement arrived and the plane departed. (IOW.)

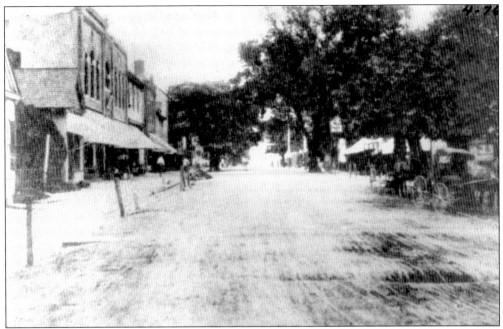

MAIN STREET, SMITHFIELD. This *c.* 1900 postcard shows unpaved streets and hitching posts but also telephone poles. This is from a 1910 article in *Southland Magazine*: "Smithfield is located on a bluff overlooking the Pagan River. . . . As the crow flies it is about twelve miles from Newport News and twenty five from Norfolk. It is a quaint and interesting old place, and there is in connection with her history, much of vast interest." (IOW.)

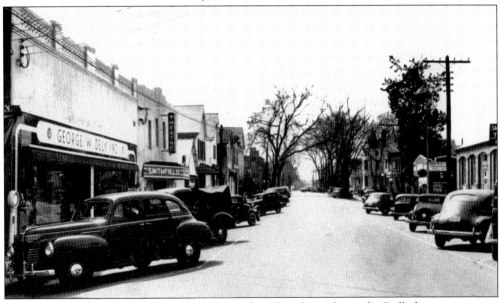

YOU CAN ALWAYS GO, DOWNTOWN. This early 1950s photo shows the Delk department store (223 Main Street) and Smithfield Theatre. Across the street is *The Smithfield Times* newspaper. Delk's opened in 1898 and served Smithfield for 103 years; it is now Antiques Emporium. The theatre was torn down in the mid-1960s to make room for a variety store. *The Times* was founded in 1920 and has been published by John Edwards since 1986. (IOW.)

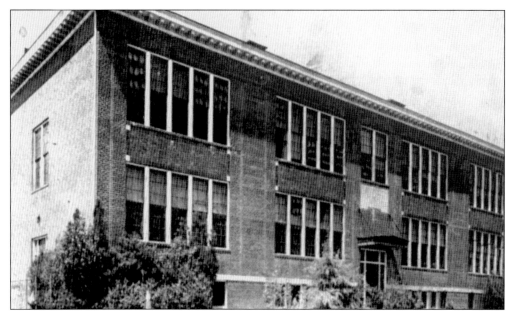

SMITHFIELD HIGH SCHOOL. After the Civil War and during Reconstruction, a new state constitution in 1869 called for a system of public schools. By 1871, there were 25 schools in the county: 20 for whites and 5 for African Americans, in addition to several private institutions. This vintage postcard shows the new Smithfield High School on James Street in 1922. Today, there is a new high school, and this building houses the public library and a campus of Paul D. Camp Community College. (IOW.)

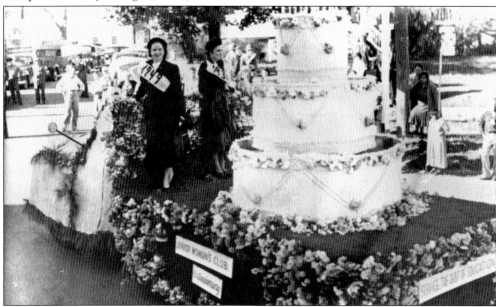

HAVE YOUR CAKE AND EAT IT TOO. As part of the 1949 Smithfield High School Homecoming Parade, the Junior Woman's Club of Smithfield celebrated its 15th anniversary. Shown are the 1949 president Mrs. James T. Humphreys, at left, and the 1934 president Mrs. Julius D. Gwaltney. The homecoming parade was a big deal in town, with everyone coming out to participate. (IOW.)

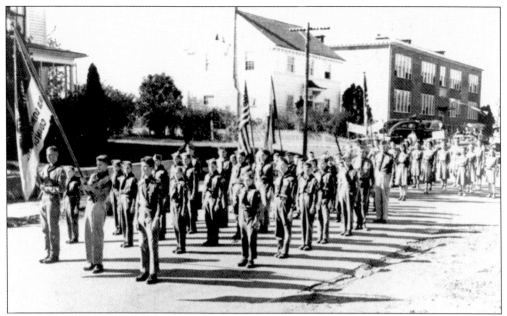

EVERYBODY LOVES A PARADE. Boy scouts and girl scouts march down James Street near Smithfield High School during the school's 1949 homecoming parade. Today, the town celebrates with Olden Days, the Pig Jig on the Pagan, and the Isle of Wight County Fair, which includes a 4-H ham curing competition. (IOW.)

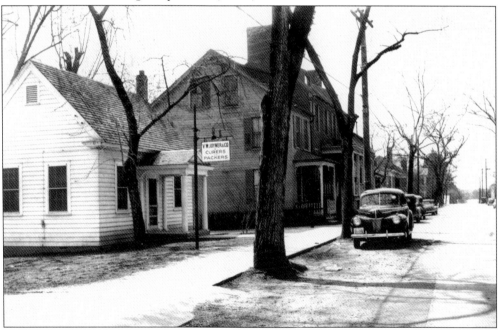

PIGGING OUT. With the increased popularity of Smithfield ham came an increase in ham producers, like V.W. Joyner; its Main Street headquarters are shown in this c. 1945 photo. Joyner, like Gwaltney and Chapman, began as a general store that sold dry goods, but it also cured meats either crafted by the store owner himself (some, like Joyner, had their own smokehouse out back) or acquired through purchase or barter with local farmers. (IOW.)

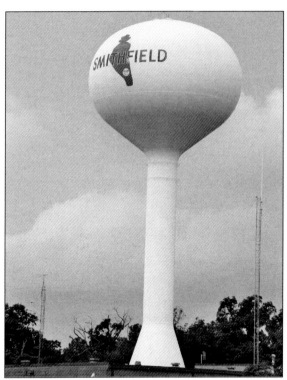

HAM ON HIGH. As if the smoky, sweet aroma that often wafts over the town of Smithfield isn't enough of a delicious reminder that this is the Ham Capital of the World, the water tower just off Route 10 tells folks that in these parts, ham is king. The town is proud of its ham heritage, and rightfully so. (PEH.)

THE BISCUIT SEEN 'ROUND THE WORLD. This charming artwork by area artist Miriam Birdsong promotes the World's Largest Ham Biscuit, constructed in 2002 to commemorate Smithfield's 250th anniversary. A charming Colonial seaport with quaint homes and shops, Smithfield is home to frequent cues of the importance of the meat industry in town. There is an annual Pig Jig on the Pagan to celebrate the connection. (IOW.)

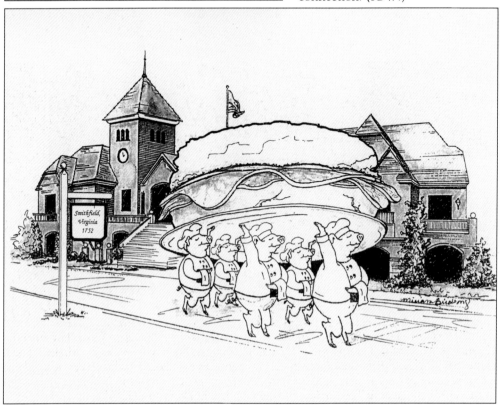

Three

THE HOG FATHERS

These guys want to make you an offer you can't refuse—smoky, sultry, rich, and otherworldly country ham. They are names synonymous with the culinary delight: Todd, Gwaltney, Joyner, Sprigg, and Luter. Each has left its mark on the ham industry and shaped it to what it is today. One, Joseph W. Luter III, head of Smithfield Foods, is still leading the way. With his son, Joseph W. Luter IV, on board, the company retains its family heritage, has become a worldwide marketer of pork products, is one of America's largest meat companies, and is poised for significant growth and expansion.

It all started with colonists who cured meat from the abundant number of hogs. Originally cured to preserve the meat, now Smithfield hams are crafted for their epicurean qualities.

The first hams were sold in the late 18th century, and the first quarter of the 20th century saw a rapid growth of the Smithfield meat industry. Although most of the process is still done traditionally, mechanization, along with improvements in transportation, helped with the increase. With the marketing genius of P.D. Gwaltney Jr., Smithfield hams became a household name and an American tradition.

Although some folks in these parts still cure their own hams, it is done more as a curiosity than for sustenance or monetary gain. There are some smaller packing houses, but the majority of Virginia country hams, and all genuine Smithfield hams, come from Smithfield Foods.

What a delicious business to be in.

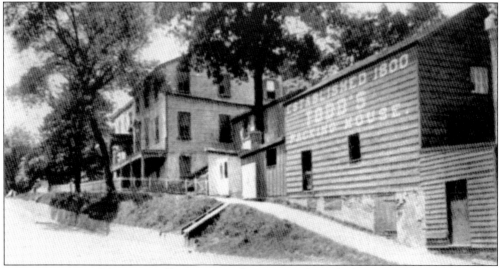

TODD'S PACKING HOUSE AND RESIDENCE. This *c.* 1910 photo, looking up Wharf Hill from the Pagan River, shows the old packing house and residence built and owned by Mallory Todd, pioneer in the Smithfield ham industry. It was continuously owned by his lineal descendents for more than 100 years. The home remains; the packing house, built in 1786, was torn down in the 1950s. Today, the Todd brand is owned by Smithfield Foods. (IOW.)

47

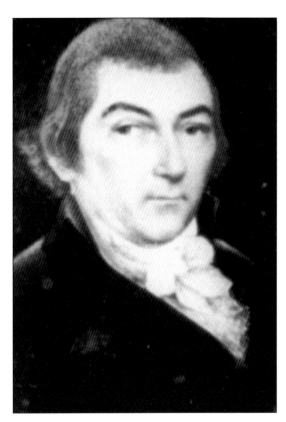

CAPT. MALLORY TODD. Bermuda-born Mallory Todd (1742–1817) was the father of the Smithfield ham industry. After his death, his son, John R. Todd, ran the business until his death in 1862, when John's son, Everard M. (E.M.) Todd, took over the task. In 1907, E.M. retired at age 79 and contracted with his son-in-law, Tazewell T. Spratley, to manage the company and with W.S. Forbes Co. to pack using the name Todd's Ham. (IOW.)

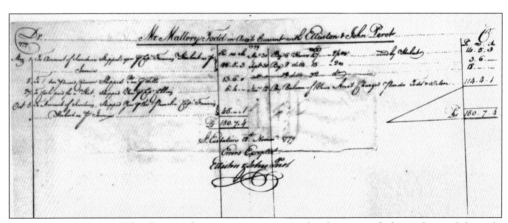

RECEIPT FOR HAMS. This late 18th-century invoice is the first recorded incident of the sale and exportation of Smithfield hams, although hams had been shipped to some extent prior to this from the Virginia colony. This receipt shows that Capt. Mallory Todd shipped hams and other goods to Ellerston and John Perot on the isle of St. Eustatius in the West Indies in 1779. (IOW.)

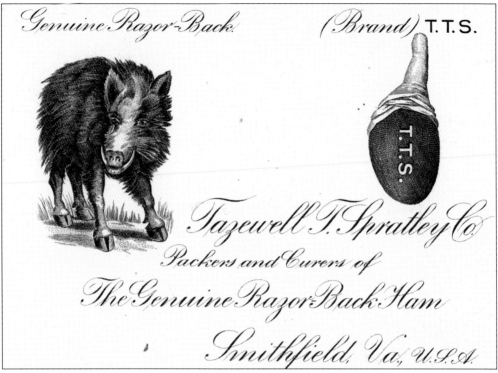

TAZEWELL T. SPRATLEY. E.M. Todd died in 1907, and W.S. Forbes Co. of Richmond began packing Todd's Ham, for a while contracting with V.W. Joyner to do the job. E.M. Todd Company remained in Richmond until purchased by the Smithfield Companies in 1998; Smithfield Foods bought it in 2001. Spratley leased the old Todd smokehouse and produced hams under the name T.T. Spratley, using a shaggy razorback hog as an icon. (IOW.)

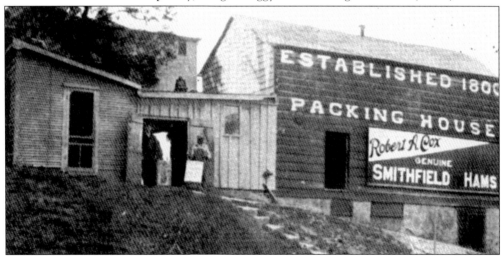

NEW PAINT JOB, SAME SMOKEHOUSE. After a succession of deaths, the old Todd smokehouse passed from the E.M. Todd Company to the T.T. Spratley Company to the Robert A. Cox Company, as displayed in this *c.* 1925 photo showing a new coat of paint and a sign added to the structure. Cox operated it until 1935 when he became ill. His recovery was slow, and he closed after 15 years of operation. (IOW.)

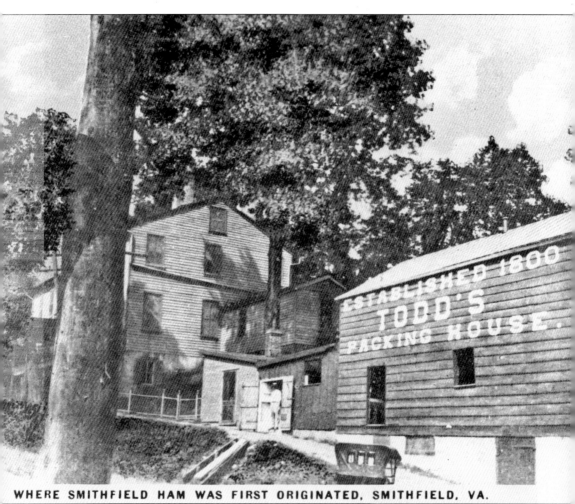

WHERE SMITHFIELD HAM WAS FIRST ORIGINATED, SMITHFIELD, VA.

END OF AN ERA. The old Todd smokehouse was in continuous use for a period of 157 years, until Robert A. Cox Company closed shop in 1935. The Smithfield Packing Company acquired the lot in 1944 from Cox, and sometime in the 1950s, the packing house was demolished, bringing the end of an era in the ham industry. (IOW.)

JOE TYNES. Joe Tynes, seen in this *c.* 1925 photo, was a longtime employee of the E.M. Todd Company and knew the intricacies of curing meat. When the company was taken over by W.S. Forbes Co. following E.M.'s death, Tynes helped Tazewell T. Spratley cure hams to the same quality he cured with Todd's. Spratley died in 1916, and the operation was then run by J. Wilbur Cox. (IOW.)

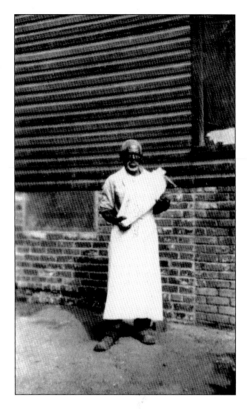

ROBERT A. COX COMPANY. Tazewell T. Spratley ran his own ham operation from 1907 until his death in 1916. J. Wilbur Cox leased the Spratley name and brands until his death in 1920. In 1921, Robert A. Cox (shown in this *c.* 1920 photo) took control of the business and the old Todd packinghouse until an illness in 1935. He closed shop, and the smokehouse sat vacant until it was demolished in the 1950s. (IOW.)

MORE PIGS THAN PEOPLE. Early colonists brought pigs with them from England to be bred for food; in the mild climate they flourished, and soon there were more pigs than people. Some pigs, as they pastured, disappeared into the swamps and forests and became feral, developing into the rangy razorback hog. Many were rounded up and placed on an island in the James River, still known as Hog Island to this day. (IOW.)

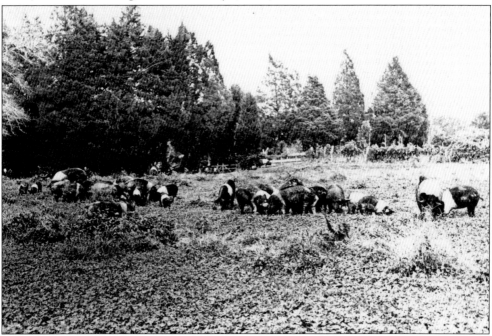

PLEASE PASS THE PEANUTS. Razorbacks and farm-raised hogs were allowed to roam in peanut fields after harvest, getting fat on the legume. The flavor of the sweet and oily nuts gave the hogs a distinctive taste and, coupled with a tried-and-true curing and smoking method, made hams produced in this region a favorite worldwide. Here, pigs feed in a field at the Minga farm in Rescue, Virginia, c. 1950. (IOW.)

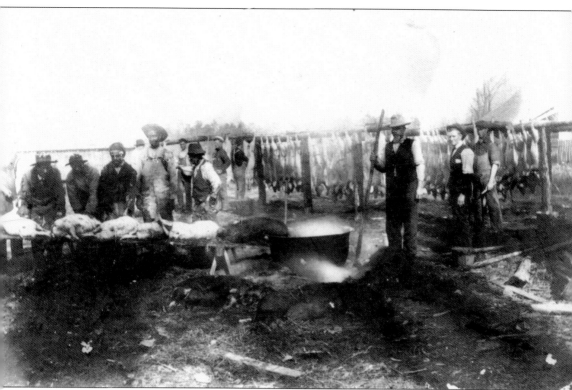

HOG KILLING TIME. In times past, all across rural America, once the weather turned cold, it was hog killing time. The main goal was to prepare meat for the coming year and to preserve it the best way folks knew how, but it also became a social event where neighboring families would gather and assist each other in a festive atmosphere. In this early 20th-century photograph at Walter L. Bryant's farm near Carrsville, there are 25 hogs hanging and 5 laid out on tables. Bryant killed about 100 hogs for sale each year. While the men were doing the butchering, women would be close by rendering the lard. Because the weather was cold, the meat could cure and age without refrigeration and risk of spoiling. By the time warmer weather returned, the salt used in curing would have penetrated to the bone, thus preserving the meat. Some meat would be consumed at that time, and more would be aged a bit longer. Today, hams are cured and smoked more for the unique flavor imparted in the process rather than spoilage retardation. (IOW.)

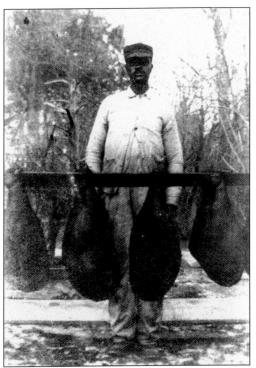

FROM SMALL TIME TO BIG BUSINESS. For years, almost every farm in rural America had its own smokehouse. Done first by the colonists, curing hams to preserve the meat for future consumption was a true necessity. The plus side was the wonderful taste of the finished product, which led to more and more being sold and to the ham industry today. The man in this *c.* 1907 photo shows the hams he cured. (IOW.)

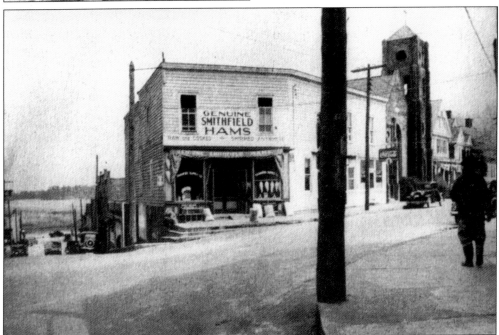

GENUINE SMITHFIELD HAMS. A banner promoting genuine Smithfield hams, as well as some of the product hanging in the window of the Farmers Supply Company, attracted motorists traveling Highway 10 (Church Street), which was at the time the main road from Norfolk to Richmond, as evident in this *c.* 1930 photo. The building, since demolished, was at the top of Wharf Hill, just a block from the packing and smoking houses. (IOW.)

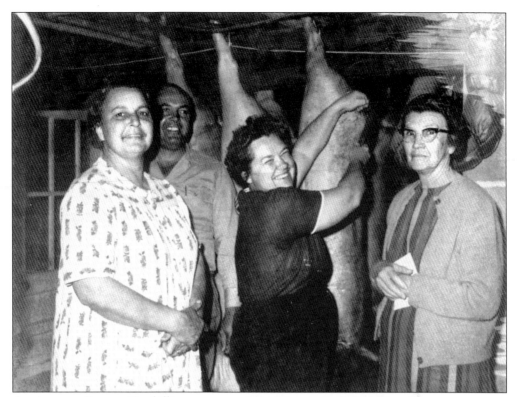

AN ANNUAL EVENT. Hog killings were two days of hard work; slaughtered first and allowed to chill in the winter air overnight, hogs were butchered the next day. Neighbors gathered to help each other, as shown in this 1950s photo of the Rose and Joyner families, who killed hogs annually at Blanche Joyner's home in Walters, Virginia. From left to right are Frances Rose, James Joyner (who raised the hogs), Nell Joyner, and Blanche Joyner. (IOW.)

AN ART AND A SCIENCE. Curing hams takes skill and practice. This *c.* 1964 photo shows a 4-H hog competition at the Isle of Wight County Fair. The man on the right is Herb Bateman, who later became a state congressman. Even today, part of the county fair includes a 4-H competition for ham curing to carry on the tradition. (IOW.)

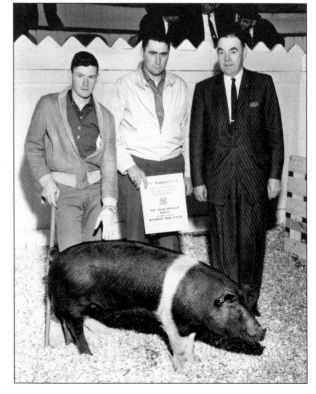

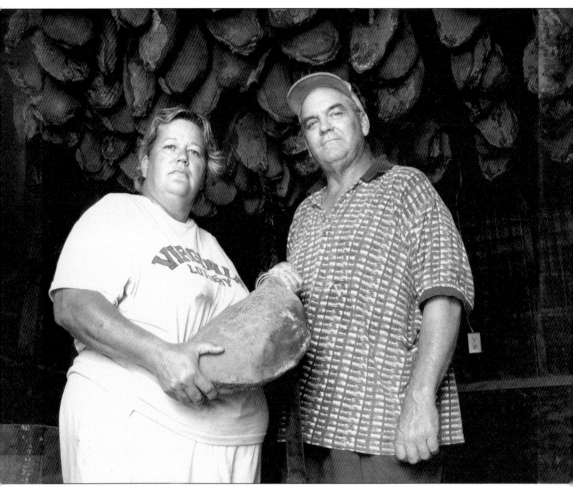

DARDEN'S COUNTRY STORE. One of the few remaining country stores open in the region, Darden's Country Store is run by farmers Tommy and Delores "Dee Dee" Darden, a husband and wife team. The 60-year-old store and 600-acre farm are located just west of Smithfield, at the corner of Bowling Green and Carroll Bridge Roads. It was the farm of Tommy's parents, L. Seward and Vivian Darden. Part of the farm includes a smokehouse, built in 1952, from which some 800 country hams are smoked each year; some are sold whole, and some are sliced and sold at the store by the pound or stuffed between two slices of white bread for a wonderful lunch. The Dardens cure their ham the old-fashioned way, as taught to Tommy by his father. The flavor is rich and complex and a true taste of tradition. Folks place orders for the Dardens' hams early each year, because Tommy and Dee Dee don't plan on making their operation any bigger. "It's the size that suits us and the smokehouse," Dee Dee says. (PEH.)

HAM I AM. For years, the name Gwaltney was synonymous with ham. The association started with a partnership between P.D. Gwaltney Sr. and P.D. Jr. in the operation of this mercantile store (photo *c.* 1935) on Commerce Street in 1886. P.D. Sr., who was involved with the peanut industry, let P.D. Jr. mind the store, which sold, among other things, "fine Smithfield hams." P.D. Jr. expanded the meat packing aspect in 1906. (IOW.)

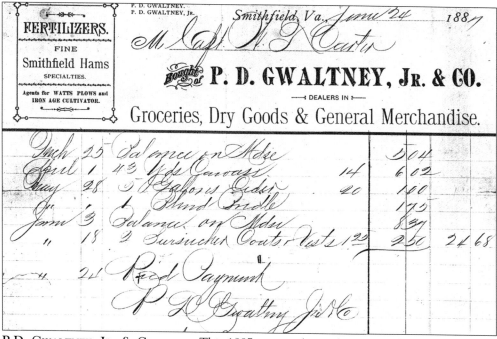

P.D. GWALTNEY, JR. & COMPANY. This 1887 receipt shows the partnership between father and son, and the emphasis on Smithfield hams. In 1906, P.D. Jr. modernized his curing and smoking buildings, which were behind the Commerce Street store, doubling the facilities, later known as Plant No. 1. New facilities would be beneficial when federal inspection of meat started in 1907. (IOW.)

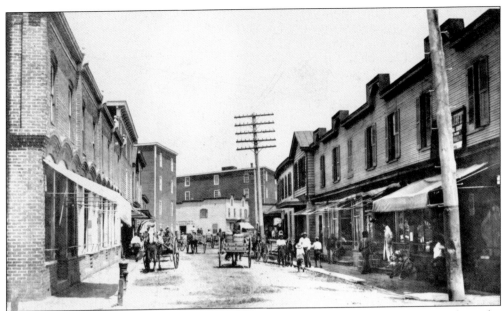

COMMERCE STREET. The top photo, from 1910, shows the busy commercial street along the Smithfield waterfront. Behind the factories, docks welcomed steamships ferrying passengers and parcels. In the forefront of the photo is P.D. Jr.'s general store. This is from *Southland Magazine* of the same year: "The two chief ham packing establishments are the P.D. Gwaltney Jr. & Company, which concern, about forty years ago, took over the business long ago established by P.D. Gwaltney Sr. and V.W. Joyner, packer of the celebrated Todd hams. These houses have an established clientele, a portion of which is abroad. It is a fact that the ham curers have their full supply of hams sold, as a rule, as early as the first of March of every year." The bottom photo from 1991 shows the original Gwaltney store, which was soon after demolished. (IOW.)

PEMBROKE DECATUR GWALTNEY SR.
This 1910 photo shows P.D. Sr., born in 1836. He owned a gunsmithing business in Norfolk as early as 1859 and served in the Surry Light Artillery Unit during the Civil War. In 1870, after the war, he partnered with his cousin, O.G. Delk, to start a mercantile, freighting, and meat packing concern in Smithfield. Later P.D. Sr would be involved in the peanut industry and telephone business. He died in 1915. (IOW.)

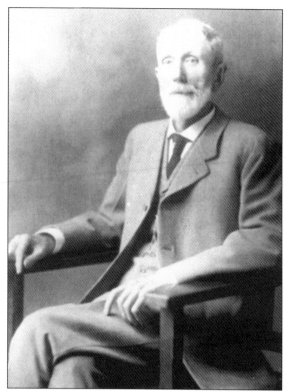

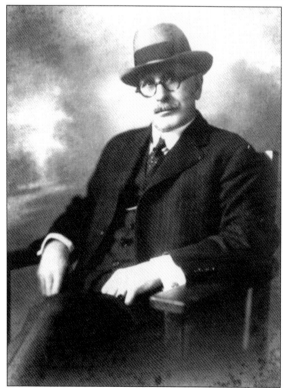

PEMBROKE DECATUR GWALTNEY JR.
P.D. Jr. is shown in this *c.* 1930 photo. Born in 1861, Gwaltney was a natural businessman, knowing how to garner interest and publicity in his product. The business he created was family run until Gwaltney Incorporated went public in 1967. After his sons retired in the late 1960s and early 1970s, no more Gwaltneys were in the business. He died in 1936. (IOW.)

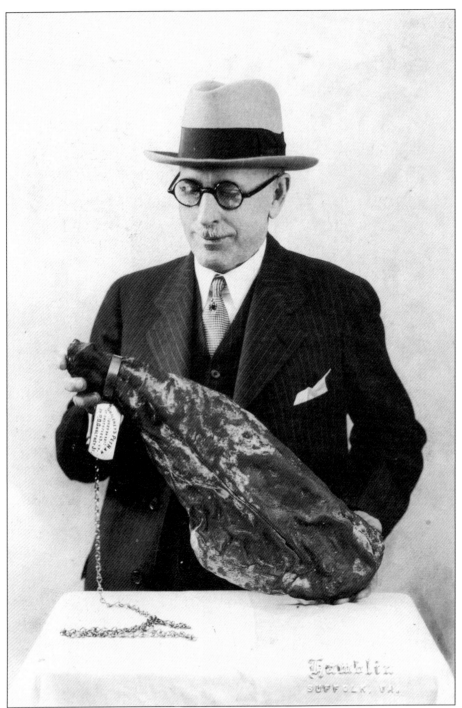

A MAN AND HIS HAM. In 1902, Gwaltney was shipping out some hams, and a worker discovered one had gotten left behind. Deciding to see just how long the curative properties of a Smithfield ham would last, he adopted it, and by the 1920s, P.D. Jr. had given it an engraved brass collar and insured it for $1,000 against fire and theft. He carried the ham around the country to food fairs and exhibitions. This photo is *c.* 1924. (IOW.)

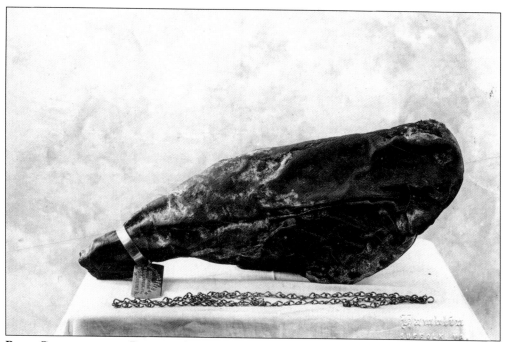

PORK-CRASTINATION. Because of a missed shipment, the ham in this c. 1924 photo was left hanging around a storeroom until noticed by a Gwaltney employee. Always looking for a photo opportunity, P.D. Jr. took the ham as his "pet" and began showing it off at shows and fairs. Although it continued to dehydrate, it was still "sound and fit to eat" even two decades later, he said. The ham is still around, although not very appetizing today. (IOW.)

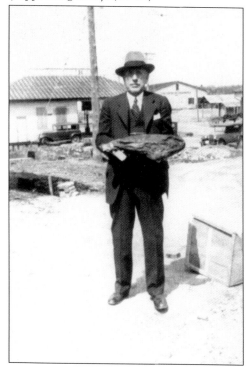

A ROOM WITH A VIEW AND A VAULT. Quite a stir was created in 1934 when P.D. Jr. asked a desk clerk at a Washington hotel to put his suitcase in the hotel vault. The desk clerk asked what was in the suitcase, and Gwaltney explained that it was his "pet ham," which was originally insured for $1,000 but increased to $5,000. The next day, a Washington paper carried the story about the incident. The photo is c. 1933. (IOW.)

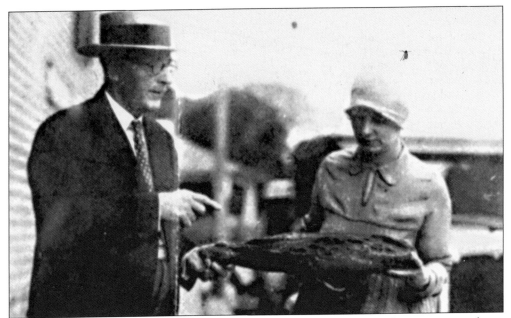

TOTALLY BOAR-ED. There was never a dull moment around P.D. Jr., part businessman and part showman. From this July 29, 1928 clip in the *Richmond Times-Dispatch*: "Mr. Gwaltney shows 'Betty' one of his Smithfield hams cured in 1902—26 years ago. Although never introduced to cold storage, the Smithfield ham remains sound and sweet." This was perfect advertisement for the durability of Smithfield hams. (IOW.)

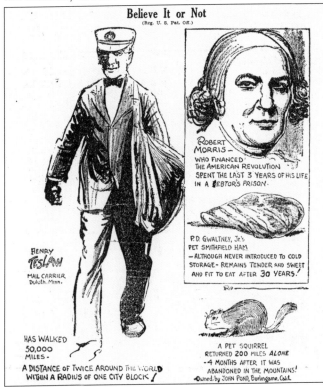

YOU DON'T LOOK A DAY OVER 30. This was the second time P.D. Gwaltney Jr.'s pet Smithfield ham garnered mention in Robert Ripley's syndicated cartoon/column "Believe It or Not." The article ran in 1932, 30 years after the pet ham was cured. It says the ham "remains tender and sweet and fit to eat after 30 years!" (IOW.)

"THE HAM WHAT AM!" That was the caption for the first story of P.D. Gwaltney Jr.'s pet ham in Ripley's "Believe It or Not." The item also reads, "27 years old—insured for $1,000." It does, however, incorrectly identify Gwaltney as a resident of Suffolk, Virginia, not Smithfield. (IOW.)

Believe It or Not By Ripley

CONTRADICTING PROVERBS
LOOK BEFORE YOU LEAP
HE WHO HESITATES IS LOST

Suggested by
Morris Kudalsky
Brooklyn.

A RAPHAEL MASTERPIECE
(Ritratto di / Fattorino)
WAS SOLD AT AUCTION
FOR ONE DOLLAR.
1816.

ELK ANTLERS
6 FT. 7 IN. WIDE
(40 POINTS)
Owned by W.J. Sheard
of Tacoma, Wash.

THE HAM WHAT AM !
27 YRS. OLD — INSURED FOR $1000
owned by P.D. Gwaltney, Suffolk, Va.

[On Request Cartoonist Ripley Will Send Full Proof and Details of Anything Depicted by Him.]

CAN YOU BELIEVE IT? The pet ham is 101 years old and still getting publicity; P.D. Jr. would be very proud. A likeness of the ham, along with information about its display at the Isle of Wight County Museum in Smithfield, appeared in this contemporary version of the popular "Believe It or Not" cartoon. (IOW.)

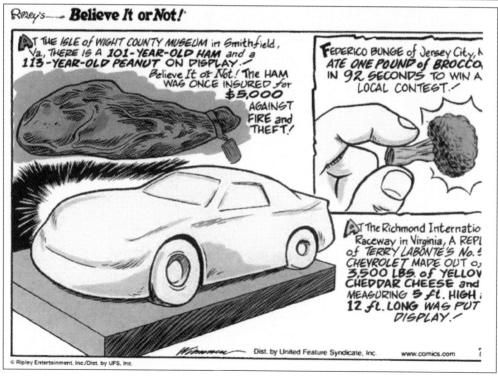

Ripley's — **Believe It or Not!**

AT THE ISLE of WIGHT COUNTY MUSEUM in Smithfield, Va, THERE IS A 101-YEAR-OLD HAM and a 113-YEAR-OLD PEANUT ON DISPLAY.
Believe It or Not! THE HAM WAS ONCE INSURED for $5,000 AGAINST FIRE and THEFT!

FEDERICO BUNGE of Jersey City, ATE ONE POUND of BROCCO IN 92 SECONDS TO WIN A LOCAL CONTEST.

AT The Richmond Internatio Raceway in Virginia, A REPL of TERRY LABONTE'S No. CHEVROLET MADE OUT o 3,500 LBS. of YELLOV CHEDDAR CHEESE and MEASURING 5 ft. HIGH 12 ft. LONG WAS PUT DISPLAY.

Dist. by United Feature Syndicate, Inc. www.comics.com

© Ripley Entertainment, Inc./Dist. by UFS, Inc.

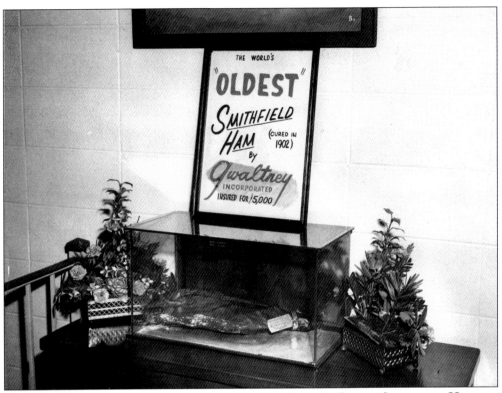

THE WORLD'S OLDEST SMITHFIELD HAM.
Before the pet ham was donated for display at
the Isle of Wight County Museum, it was
kept under glass in the lobby of Gwaltney's
main offices for the public to see, as shown in
this June 1964 photo. Also at the museum:
the largest ham ever cured by Gwaltney: a 91-
pound ham that weighed 65 pounds after
curing. (IOW.)

WHAT, NO FORTUNE COOKIE? This unusual
request came into Gwaltney in 1931 but
went unfulfilled as no one in Smithfield read
Chinese. P.D. Jr. took the letter to Charlie
Wong, a laundryman in Suffolk. Wong asked
P.D., "You pig man?" and told him the letter
was an order for one dozen hams. The hams
were sent on to the person who ordered
them in Boston. The incident made national
news. (IOW.)

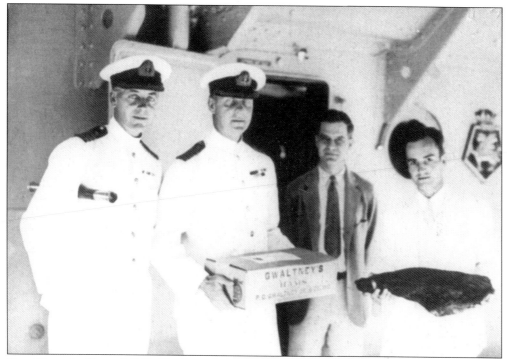

BUT DOES IT FLOAT? P.D. Gwaltney Jr.'s pet ham (being held by Julius Gwaltney, right) is shown to Capt. W.F. Wake-Walker, left, commanding officer of the HMS *Dragon*, a British cruiser in port in 1943. He was also presented an edible, baked Smithfield ham. The photo ran in papers nationwide; it was another publicity opportunity to get the Gwaltney name in print. (IOW.)

THE PRICES, THEY KEEP A-CHANGIN'. Because of their craftsmanship, Smithfield hams have never been cheap. From *Southland Magazine*, 1910: "Nowhere can we go . . . that we do not find upon the menus of the most exclusive hotels and restaurants, the Smithfield ham quoted at a price far in excess of the price asked for any other ham." The cost per pound in 1912 was about 16¢; today, it tops $4. (IOW.)

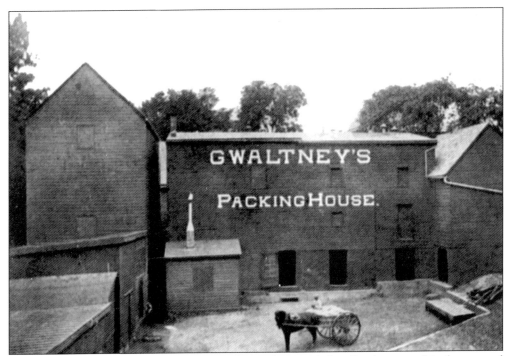

THE CELEBRATED SMITHFIELD HAMS. These photos of the Gwaltney packinghouse and warehouse were shown in the September 1910 issue of *Southland Magazine*. The caption for the top photo read, "P.D. Gwaltney Jr. and Company, the largest packers of the celebrated Smithfield hams. The summertime idleness of this plant is little suggestive of its great activity throughout the rest of the year." Business did boom, and so did the need to expand. Because a state law specified genuine Smithfield hams could only be "cured, treated, smoked and processed in the town of Smithfield" and because the town limits were pretty small, part of the county across the Pagan River was annexed in 1960 to include the meat packing plants on that land. By doing so, the meat industry grew, as well as the town's population, which doubled overnight. (IOW.)

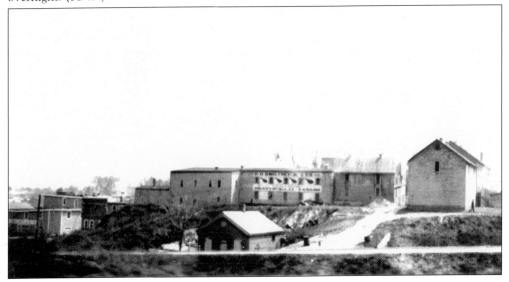

OLD SMOKEHOUSE ON THE HILL. This early 1930s photo shows the Gwaltney smokehouse up the bluff from the Pagan River. As the company moved across the river to new facilities, a member of the Gwaltney family penned "The Old Plant on the Hill" in 1962, which read, in part, "Its rafters smell of hickory smoke / Its cellars bleak and cold / Its fame has spread around the world / Its color, yellow gold." (IOW.)

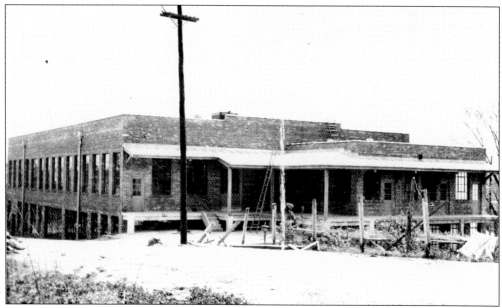

MOVE ALONG, LITTLE PIGGIES. This is a shot of Gwaltney Plant No. 2. Gwaltney and the town's other five meat packing companies got a short-lived boost in transportation with the operation of the Smithfield Terminal Railroad (STRR) from 1948 to 1951; it was the first and only railway to operate here, running one mile of rail and connecting with a tug/carfloat to Newport News to hook with the Chesapeake & Ohio Railroad. Trucking proved more beneficial. (IOW.)

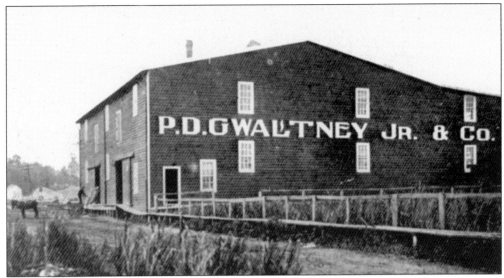

GWALTNEY WAREHOUSE. This 1910 photograph from *Southland Magazine* has a caption that reads, "A warehouse in which is stored vast quantities of fertilizer, used in the growing of peanuts and other products for which this section is noted." Although some of these warehouses along Commerce Street would survive the Great Smithfield Fire of 1921, they would not make it to the new millennium before being knocked down after years of sitting vacant. (IOW.)

COMING DOWN. This July 1991 photo shows the demolition of the P.D. Gwaltney Jr. and Company Warehouse No. 12. Most of the warehouses and smokehouses along Commerce Street, including the original Gwaltney store, had fallen into disuse and disrepair and were torn down in 1991. Like the demolition of the old Todd smokehouse, it was an end of an era. This photo was taken by Atwill Gwaltney. (IOW.)

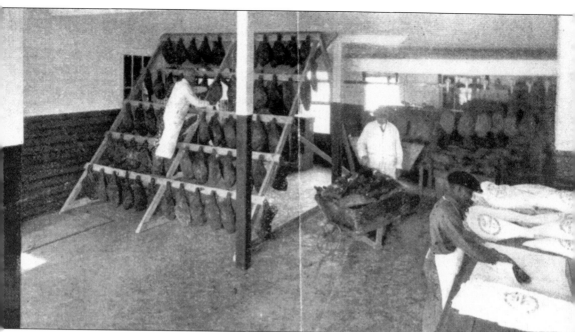

TESTING AND PACKING SMITHFIELD HAMS. This *c.* 1933 photo shows workers at the P.D. Gwaltney Jr. and Company Plant No. 1 testing and packing hams, sides, and shoulders. In the center is Joseph W. Luter Sr., who worked with Gwaltney from the early 1900s until 1936. Luter was born on a farm near Ivor, Virginia, in 1879 and began his career with Gwaltney at an early age. Joseph W. Luter Jr. was born in 1908. When Joseph Jr. was about 10 years old, he started assisting his father, who was losing his sight, on sales calls for Gwaltney Packing. Joseph Jr. himself went to work for Gwaltney, learned all phases of operation, and worked his way up to plant manager. He felt there would be room for little more advancement with Gwaltney since it was such a tightly-held family company, and he persuaded his father to start their own meat packing plant. That became Smithfield Packing Company, a predecessor to Smithfield Foods, today run by Joseph III. Gwaltney Packing became a subsidiary of Smithfield Foods in 1981. (IOW.)

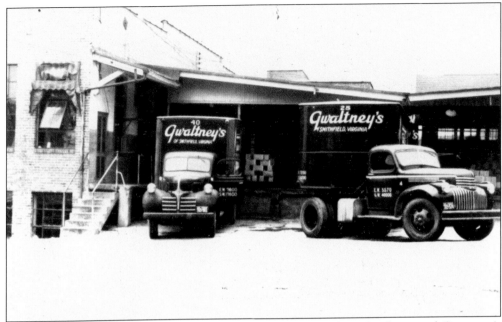

GWALTNEY PLANTS. The above photo shows the loading dock at Gwaltney and Company's Plant No. 2 in 1954. This plant began operation in 1936 as a slaughterhouse and fresh pork packing plant. Before this point, all meat was purchased from area farmers as dressed carcasses or cut meat. The plant was located on the north side of the Pagan River, just outside the Smithfield town limits. In 1937, around 12,000 hogs were slaughtered, amounting to more than 1 million pounds of pork. The plant burned in 1981 and was removed in 1992. The below 1963 photo shows the Tarboro (North Carolina) Hog Market. Four decades ago, as today, hogs used in production of Smithfield hams and other pork products came from farms nationwide; Smithfield Foods purchases hogs from 11 major production states. (IOW.)

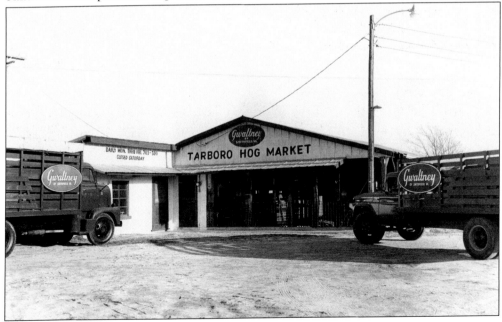

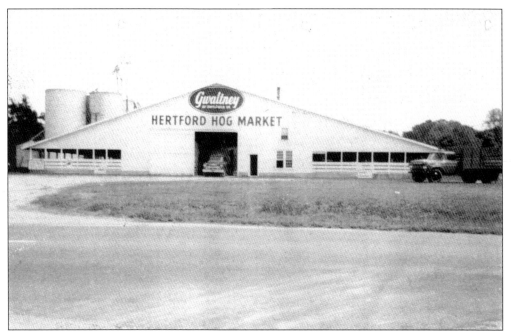

HOG MARKET. This 1962 photo shows a Gwaltney hog market building, where hogs would be processed. Today, under the Gwaltney banner, Smithfield Foods produces a number of products. Ham products include long-cured genuine Smithfield ham (cured six months or longer), Gwaltney Genuine Smithfield Ham, Luter Genuine Smithfield Ham, and Charles Henry Gray Gourmet Ham. Hams smoked and dry cured for three months include the brands Williamsburg, Gwaltney, Red Eye, and Peanut City. (IOW.)

GWALTNEY PLANT NO. 3. A $1.25-million Gwaltney expansion began in 1954 near Plant No. 2. The first phase included facilities for hog killing, cutting, by-product rendering, lard refining, and livestock yards. Plant No. 3 was completed in 1961, the same year Gwaltney Incorporated turned 90. The plant, which is still in use today, included the main office and all operations except for dry cure products. (IOW.)

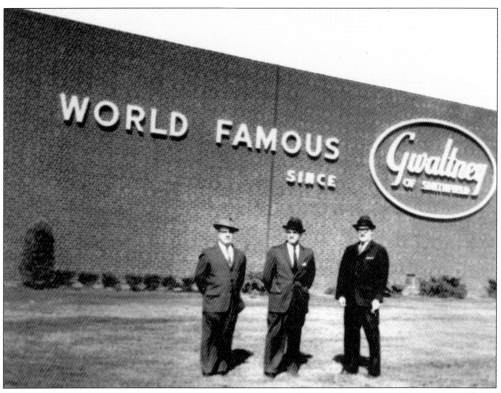

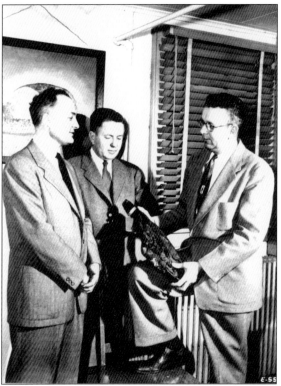

THREE GWALTNEY BROTHERS. The sons of P.D. Gwaltney Jr. stand in front of the new Plant No. 3 in 1961. From left to right are the following: secretary-treasurer and chairman P.D. III, who retired in 1967; vice president Julius, who retired in 1971; and president Howard, who retired in 1972. In 1970, Gwaltney was purchased by International Telephone and Telegraph and became ITT Gwaltney, and it was a family business no more. In 1981, Smithfield Foods purchased Gwaltney. (IOW.)

PUT THE PET HAM ON A PENSION. Cured in 1902, P.D. Jr.'s pet ham kept resurfacing for publicity photos, as shown in this *c.* 1955 picture inside Gwaltney main offices. With the ham are, from left, sales manager Gene Emory, salesman V.A. Saunders, and assistant secretary-treasurer Walter H. Shearin. Want to see the pet ham yourself? It's on display at the Isle of Wight County Museum. (IOW.)

SWINE-O-MITE. It was a time to celebrate in 1961 with the completion of Plant No. 3. This vintage photo is from the giant open house Gwaltney held on April 9, 1961, in honor of the occasion and the company's 90th anniversary. Some 11,000 folks came from near and far to enjoy tours, refreshments, favors, and prizes. (IOW.)

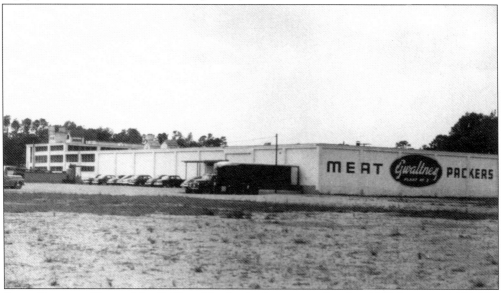

FIRST PHASE OF PLANT NO. 3. Plant No. 3, which was completed in 1961, began in 1954 (the believed date of this photo) and included kill and cut floors, fresh meat coolers, shipping and stocking facilities, a lard room, and inedible rendering facilities. With these additions, Gwaltney, which would change its name to Gwaltney Incorporated in 1957, began to grow rapidly and successfully. (IOW.)

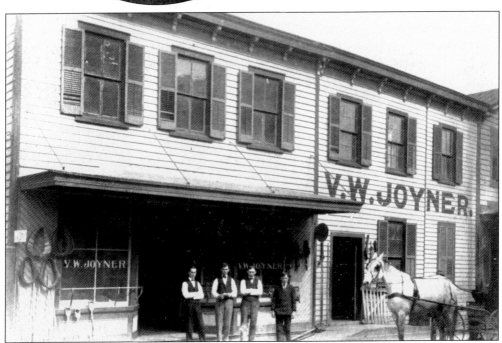

V.W. JOYNER. Vincent W. Joyner was another important player in the Smithfield ham industry. Born in 1862 near Orbit, Virginia, Joyner and his brother, Willie, started a dry goods business in Smithfield in 1891, which sold a variety of items, including cured meat from area farmers. By 1897, his ham curing and packing business was growing. (IOW.)

THE BEGINNING OF THE **V.W. JOYNER & CO.** This c. 1900 photo shows the adjoining buildings on Commerce Street, bought by W.W. "Willie" Joyner and Vincent W. "V.W." Joyner. Both were used as the general mercantile store of V.W, who sold clothing, canned goods, notions, and light hardware. Local farmers began selling and bartering hams with Joyner, who displayed them hung, uncovered, from the rafters, like any other merchandise. (IOW.)

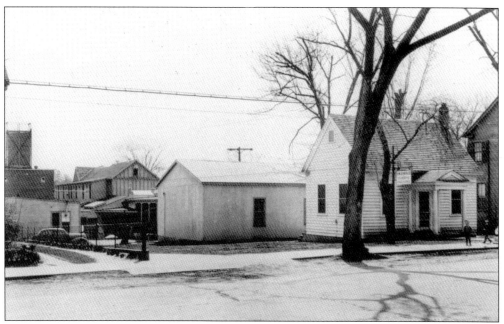

HAMMING IT UP DOWNTOWN. This *c.* 1940 photo shows one of the Joyners' buildings on Main Street in Smithfield. Much of the Joyner plant consisted of wood-framed buildings, with part of the smokehouse dating back to 1889. By the time Joyner's was acquired by Smithfield Foods in 2001, it was the only ham business left downtown—others had moved across the Pagan River to larger digs. (IOW.)

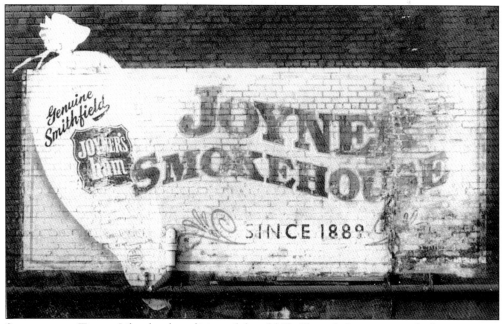

SIGN OF THE TIMES. Like the demolition of the old Todd smokehouse, an end of an era came when the 1889 Joyner smokehouse, which had been the oldest commercial smokehouse in continuous use in America, was torn down in 2001. This colorful signage was painted on the back of the wood-and-brick building, proudly boasting its claim. (Betty Thomas.)

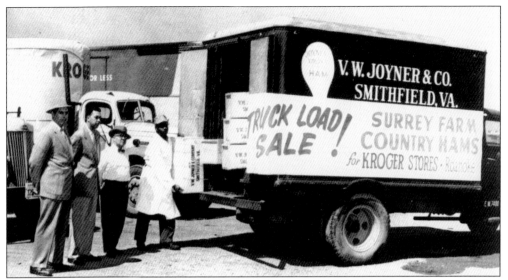

TRUCK LOAD SALE. This 1940s photo shows trucks being loaded with Joyner hams and other pork products, heading off for sale at Kroger grocery stores. Because Smithfield had no railroad, most hogs came into town and left as ham by way of truck, a method still used. In early days, hogs, which generally lived free-range, would have been taken to market in "drives," much like cattle. (IOW.)

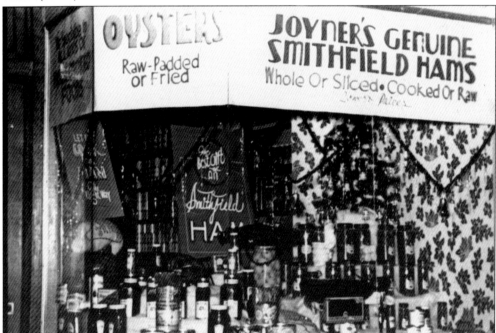

IT'S NOT THE HOLIDAYS WITHOUT A HAM. This 1941 Christmas display showcases V.W. Joyner & Co. ham, oysters, and other Virginia delicacies in the display window of Banker's Delicatessen on Broad Street in Richmond. Joyner's sold a number of items: a 1923 *Smithfield Times* advertisement boasted they were "curers and packers of Smithfield hams, Smithfield breast, Smithfield bacon, Smithfield jowls, Smithfield smoked sausage, and purest Smithfield lard." (IOW.)

A Swift Acquisition. In 1926, Swift & Company of Illinois bought V.W. Joyner & Co. Immediately, the new owners went about upgrading the buildings with a new addition to the smokehouse, making it twice its original width. An automatic sprinkler system was installed to prevent fires. In 1983, Swift sold Joyner to Smithfield Ham & Products Company, now part of Smithfield Foods, which has kept the Joyner name on many products. (IOW.)

Gone but Not Forgotten. This sign graces the Pruden Packing Company in Suffolk, a facility, part of the Joyner family, now closed. In 2001, Smithfield Foods purchased Smithfield Companies, makers of ham and other specialty food products, which operated the Smithfield Ham and Products Company, V.W. Joyner & Co., Pruden Packing Company, E.M. Todd Company, and Williamsburg Foods. It gave Smithfield Foods greater control over the Smithfield brand name. (PEH.)

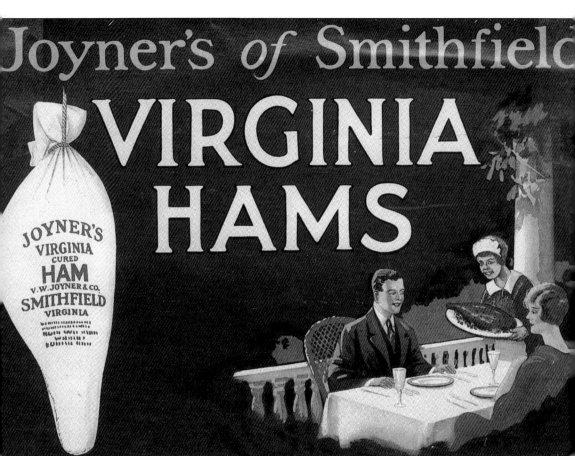

VIRGINIA HAM. This 1940s sign, on display at the Isle of Wight County Museum, advertises Joyner's Virginia-style ham. By mid-20th century, Smithfield hams began making their way across the country, in deli cases and on restaurant menus. Joyner promoted hams to retailers: "Virginia ham is actually less expensive than plain sliced chicken. . . . Dishes made with Virginia ham can command and receive a higher price, while the preparation costs no more than other dishes." During the ham heyday of the early 20th century, many companies began production, although most did not have the staying power of Joyner, Gwaltney, and others. These included Chapman & Company (1880s–1931), Smithfield Minced Ham Corporation (1936), the Smithfield Ham Corporation (1910–1915), the Virginia Ham Company (1923), and the Pocahontas Packing Corporation (1926). (IOW.)

SMITHFIELD HAMS. This white frame building, *c.* 1925, simply states "Smithfield Hams" and was the start of the Smithfield Ham and Products Company, started by Maryland-born James "Jimmy" Cresap Sprigg Jr. (1898–1989). When, at the prompting of a friend, Sprigg bought the defunct Smithfield Company for 30¢ on the dollar, he had never tasted a Smithfield ham. But he knew of them and thought the business to be promising. He moved to Smithfield in 1925, living in the two-room plant on nine acres of land just across the Pagan River, outside town limits. He started with no inventory, and because hams take months to cure, Sprigg bought and cooked hams from other companies. Because this significantly increased the cost, he marketed them to upscale customers and restaurants in New York and the like, introducing a whole new audience to Smithfield ham. (IOW.)

JAMES C. SPRIGG. To comply with a 1926 law that said genuine Smithfield hams had to be cured and processed in town limits, Sprigg's business built a packinghouse on North Main Street. It did not help his hams in 1928, however; they were so tough no one could eat them. To salvage the stock, Sprigg ground, seasoned, and jarred the ham, creating the Amber Brand Deviled Smithfield Ham product. (IOW.)

HAM-SICLE. It seems that there is no where a ham isn't welcomed. When the Norcross-Bartlett Expedition spent four months in the Arctic Ocean in 1933, ham and deviled ham were brought with them. This photo shows Arthur D. Norcross promising an Eskimo man a slice of ham if the Eskimo will carve him an ivory polar bear. (IOW.)

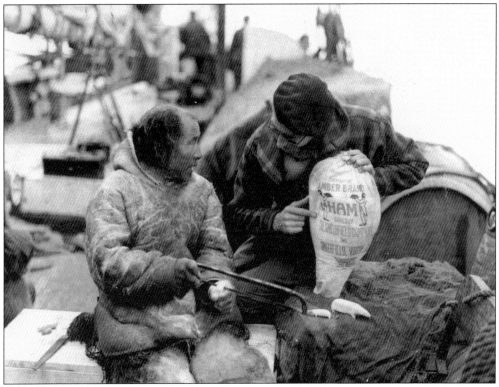

THE FIRST PIG OF VIRGINIA. Sprigg continued to focus on processed ham products, rather than whole hams, and created the Amber and James River brand of foods. In the 1930s, he traveled promoting the products, showing how they could be sold at lunch counters more expensively than a typical ham sandwich or how one might fashion an upscale appetizer from them. To go with the image, the First Pig of Virginia and, later, Smitty Pig, was created by a New York advertising agency. Sprigg spent more than $100,000 advertising nationally in the 1940s and expanded the company in the process. Sprigg ran the company until he sold it in 1981 to Peter Pruden III of Pruden Foods of Suffolk. Later, the company would acquire V.W. Joyner & Co., and then be bought by Smithfield Foods. (IOW.)

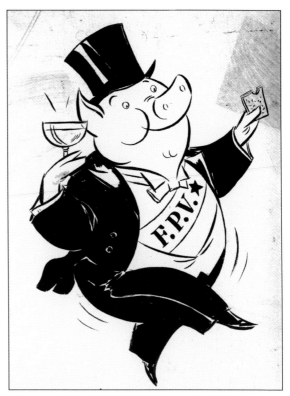

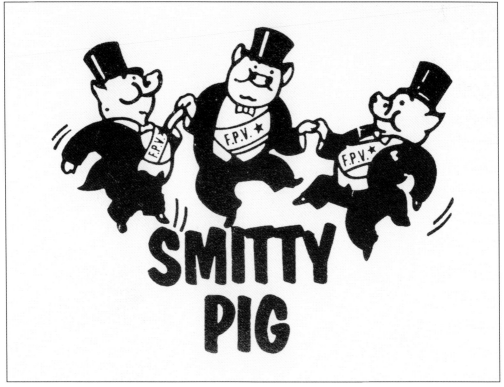

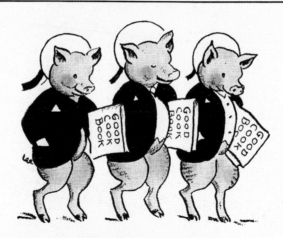

Ham a la carte

If you'd cook aright the ham
Virginia's made famous
See to it yourself madame,
Don't trust some ignoramus.
Soak one night for each year old,
(To this pay strict attention),
Afterwards scrape off the mould,
(Which merits special mention);
For each pound you find it weighs
Boil twenty minutes slowly,
Skin on taking from the blaze—
A tang that's dif'rent, wholly
Comes from pouring one full cup
Of wine or champagne to it;
(Once this sent all of U. S. up
But now it's safe to do it).
Place in pan on even keel,
Spread thickly up and down it
Sugar, pepper, cracker meal
And spice—Let oven brown it.

L'ENVOI

Tho "Pigs is Pigs" it is no myth
That they who know, continue
To find the best connected with
The Hams of "Ole Virginyuh."

Supreme in Flavor Since 1870

THE THREE LITTLE PIGS. Despite the popularity of Porky Pig of cartoon fame, animated pigs, with the exception of Sprigg's First Pig of Virginia and Smitty Pig, never took off in ham industry advertising campaigns. With the success of Mr. Peanut from neighboring Suffolk, Virginia, one would expect to see a plethora of piggies promoting Smithfield ham, but perhaps the pork executives of the day thought that if an advertising mascot looked too cute, folks wouldn't want to eat him. Gwaltney did use these three little pigs in a c. 1945 brochure, along with a creative poem to remind folks of the proper care and cooking of country hams. Despite the lack of a porcine icon (Snoop Hoggy Hogg?), many folks do enjoy ham and collecting pig-themed collectibles, some of which are sold at the Genuine Smithfield Ham Shoppe in Smithfield. (IOW.)

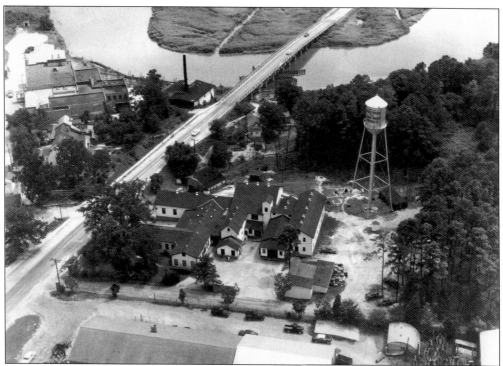

SMITHFIELD HAM AND PRODUCTS COMPANY. This 1956 aerial view of the Smithfield Ham and Products Company shows the concern's operational buildings and water tower. The company was started in 1925 by James C. Sprigg, a very colorful character whose life adventures included prospecting in the Wild West and meeting Pancho Villa. (IOW.)

THE ORIGINAL LUTER PLANT. This white-sided building is the original Luter-owned Smithfield Packing Company plant, c. 1938, which stood at the corner of Thomas and Commerce Streets at the Wharf. It was torn down after a fire in 1990. Note the smokehouse on the left with a large pile of wood. The Luters shortly afterward established a slaughterhouse in near by Suffolk, Virginia. (IOW.)

PRESENTING HAMS. This mid-20th century photo shows Joseph W. Luter Jr., right, ceremonially presenting a Smithfield ham. The Luters started their Smithfield Packing Company on a small scale—Joseph Sr., Joseph Jr., and a truck driver. It was started after both father and son had established careers with P.D. Gwaltney Jr. and Company. In 1936, Joseph Jr., who believed he had advanced about as far as possible in the family-held Gwaltney company, convinced his father to start their own enterprise. Not long after the company started, Joseph Sr. suffered a stroke, and his son took on the company's presidency. Joseph Sr. remained on the board until his death in 1947. Joseph Jr. ran the company until a heart attack claimed his life in 1962, at which time his son, Joseph III, having just graduated college, came to work at the company. After a buyout by Liberty Equities, a brief departure of Joseph III, a name change to Smithfield Foods, and a return of Joseph III, the company is now the largest pork processor in the world. (IOW.)

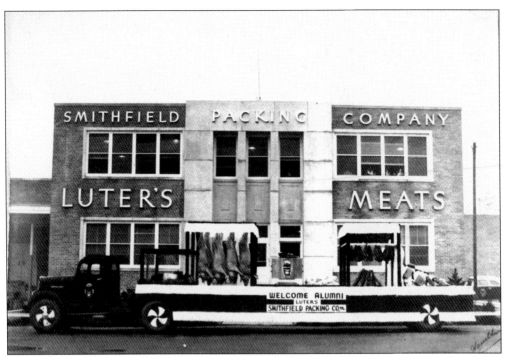

SMITHFIELD PACKING COMPANY. This 1946 photo shows the newly-opened Smithfield Packing Company building. Out front is the company's parade float; notice the live hogs on display, as well as the display of gutted hogs. The building, on North Church Street/Route 10, just across the Pagan River, is still in use today. (IOW.)

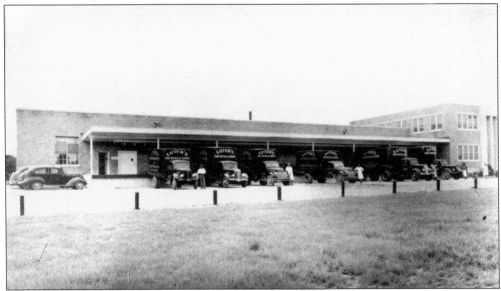

LUTER'S LOADING DOCKS. Six trucks are loading up at Smithfield Packing Company in this 1940s photo. A new, modern plant in 1946 gave Luter's the ability to slaughter as many as 3,000 hogs daily; once slaughtered, the facility could package a number of products from hot dogs to sausages. The only thing it couldn't do was create genuine Smithfield ham: the land was outside town limits until annexation in 1960. (IOW.)

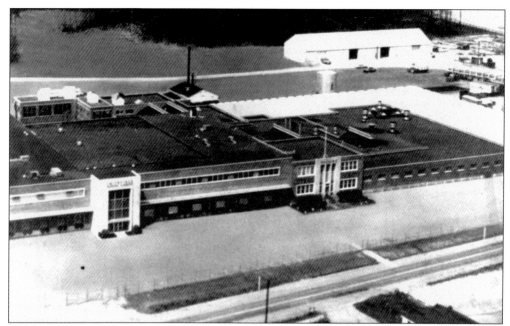

SMITHFIELD PACKING IN 1955. This aerial shot of Smithfield Packing Company shows the North Church Street facility and areas where expansion would soon follow. Even though this plant would grow and the land would fall into town limits, Luter's would continue to cure genuine Smithfield hams at the old Plant No. 2 on Commerce Street until it burned in 1990. (IOW.)

HINDQUARTERS HEADQUARTERS. Corporate home to Smithfield Foods, it is the world's largest pork processor and hog producer. The company processes 20 million hogs and raises 12 million annually. Brands include Smithfield Premium, Smithfield Lean Generation, John Morrell, Gwaltney, Patrick Cudahy, and others. Annual sales run $8 billion. Outside the United States, Smithfield Foods owns subsidiaries in France, Poland, and the United Kingdom, and it operates joint ventures in Brazil, Mexico, and China, employing more than 40,000. (CK.)

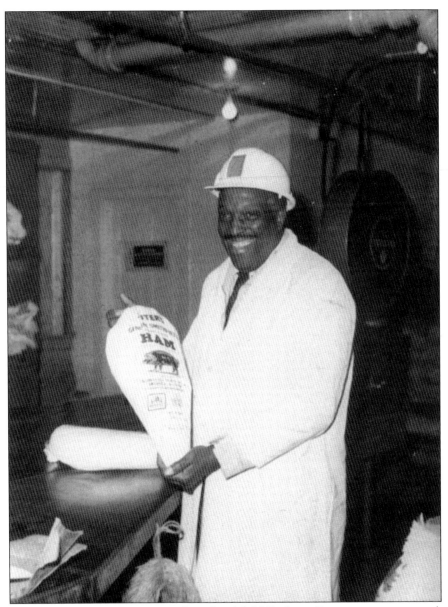

CHARLES HENRY GRAY. Starting work at Smithfield Packing Company at a very early age, Charles Henry Gray worked for three generations of Luters over a 47-year span. Charles Henry was a lifelong Smithfield resident, receiving his education at Isle of Wight Training School and Hampton Institute. He started working on the shopping dock and became an executive with the company. For three years, he was manager of the resort restaurant at Bryce Mountain, which was owned by Joseph W. Luter III. He was also a caterer who was known for his barbecue and special cured hams. Charles Henry was a colorful character, both known and liked throughout the ham industry and across town. He was a member of Main Street Baptist Church, the Virginia Department of Historic Resources, Elks Lodge 65, and Fidelis Council 18. Charles Henry was the second African American elected to the Smithfield Town Council. In 1985, he was listed in *Who's Who Among Black Americans*. Charles Henry died May 21, 1986, and is buried in Historic St. Luke's cemetery. (IOW.)

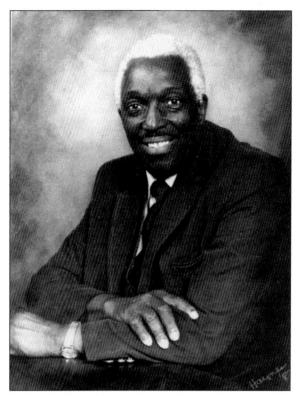

A HAM INDUSTRY ICON. Charles Henry Gray worked in every phase of the ham industry's operation over an almost 50-year span, becoming assistant to the chairman of the board. The ham industry was built on folks, many of them colorful characters like Charles Henry, who loved the business they were in. Another such person is Carter Moore, who was cure master at V.W. Joyner & Co. for going on five decades. (IOW.)

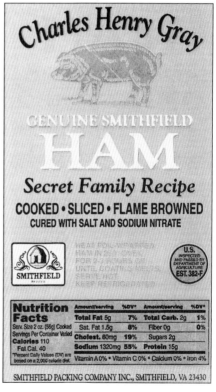

THE CHARLES HENRY GRAY PARTY HAM. This special ham, made from the Luter's genuine Smithfield ham and seasoned with a secret family recipe, was developed by Charles Henry Gray, who prepared it only on special occasions. His method has been entrusted to another Smithfield associate who guards the secret recipe, but we do know one special ingredient is brown sugar. Whatever is in the cure, it makes this a very special ham. (IOW.)

PRODUCTS THAT ARE PORK-FECT.
A variety of pork products produced by Smithfield Packing Company, a predecessor to today's Smithfield Foods, have been enjoyed since 1936, such as the whole hog in the above photo of a 1970s traditional pig pickin' or the pork barbecue that came in the 1940s container shown at right. Adapting to changing food trends, in the 1990s, the company launched Smithfield Lean Generation, a product that is bigger and meatier than ordinary pork and up to 60 percent lower in fat. It is the first line of fresh pork to have select cuts certified by the American Heart Association for low saturated fat and cholesterol. (IOW.)

LUTER'S

U.S. INSPECTED AND PASSED BY DEPARTMENT OF AGRICULTURE EST. 382

SERVE HOT OR COLD
COOKED PORK
With Barbecue Sauce
INGREDIENTS: PORK, TOMATO SAUCE, VINEGAR, FLAVORING, SALT, SPICES AND SUGAR.
NET WEIGHT 5 POUNDS
KEEP REFRIGERATED
PACKED BY
THE SMITHFIELD PACKING CO., Inc.
SMITHFIELD, VIRGINIA

JOSEPH W. LUTER III. Smithfield Packing Company had been in the Luter family since it was chartered in 1936. Joseph W. Luter Sr. remained chairman until his death in 1947, and it was run by Joseph Jr. until his death 1962, at which time Joseph III took the reigns. Joseph III (above) was born in Smithfield in 1939 and graduated from Wake Forest University in 1962. He wanted to go to law school, but following his father's death, he joined the company, working in sales and other departments until he became president in 1966, a role he kept until the company was acquired in 1969 by Liberty Equities (which changed its name to Smithfield Foods in 1971). Joseph III pursued other interests, but when his family's former business was in severe financial distress, Smithfield's board of directors asked if he would rejoin the company as chairman and CEO in 1975. Under his leadership, Smithfield Foods has grown to more than $8 billion in annual revenues and has successfully integrated more than 20 acquisitions over the past 20 years, expanding the company nationally and internationally. (PEH.)

Four
HIGH ON THE HOG

In order for a cut of pork to be classified as a ham, it must come from the hog's upper hind. It may come fresh, dry cured, or wet cured. It may come bone-in, semi-boneless, or boneless. But it takes more to become a Smithfield ham.

In order for a ham to be classified as a genuine Smithfield ham, it must meet guidelines passed by the Virginia General Assembly in 1966: "Genuine Smithfield hams are hereby defined to be hams processed, treated, smoked, aged, cured by the long-cure, dry method of cure and aged for a minimum period of six months; such six-month period to commence when the green pork cut is first introduced to dry salt, all such salting, processing, treating, smoking, curing and aging to be done within the corporate limits of the town of Smithfield."

Alas, mere words cannot alone convey the essence of a Smithfield ham; dark, rich, firm, course flesh with a complex sweet, salty flavor. It is misleading to have slices so thin that you can read through them come packed with so much flavor.

Originally conceived as a way to preserve meat as a source of protein year-round, the taste of country ham won many folks over. Today, Smithfield ham is a true epicurean delicacy; its virtues extolled by culinarians are much like that of Italian prosciutto.

Of course, something this good isn't easy to come by. The process for crafting country ham is an ancient, time-tested, and time consuming one. But it's worth the wait.

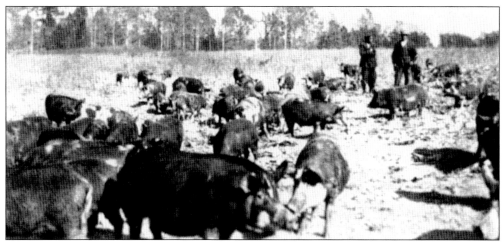

PORKY PIGS. In old days, hogs roamed the woods after April, making flesh firm and lean. Later, they were penned and turned loose in harvested fields to root for peanuts, as in this c. 1905 photo of Wright's Point Farm. Now they come from high-tech hog farms from across the country. However, to be a genuine, ham must still be cured and processed within Smithfield town limits. (IOW.)

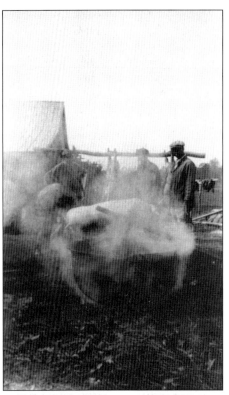

HOG KILLING AND LARD RENDERING. This *c.* 1940 photo shows the process of hog killing and lard rendering, believed to be on Wilson Holland's farm near Carrsville. After weeks of fattening, the hogs were killed, the skin scraped to remove bristles, the carcass cut open, and internal organs removed before butchering. Layers of fat were put in heated kettles and stirred constantly. (IOW.)

STACKING SALTED HAM. This 1970 photo at Gwaltney shows workers stacking pallets of salted ham in a giant refrigerated room. Layer upon layer of hams are stacked and sit for two months to give the preservative salt time to penetrate the meat down to the bone. The hams will then be smoked and aged. (IOW.)

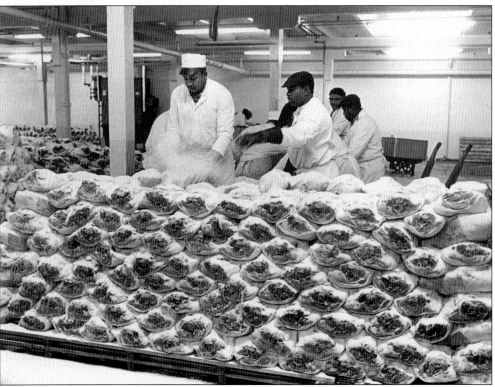

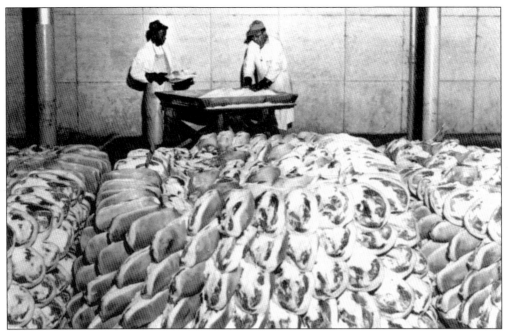

THE FOUR ELEMENTS. Although hogs destined to be Smithfield hams are no longer fed a diet of peanuts, the four basic elements used in curing hams have gone unchanged for hundreds of years: salt, pepper, smoke, and time. This *c.* 1950 photo at V.W. Joyner & Co. shows two men starting the curing process by salting hams. (IOW.)

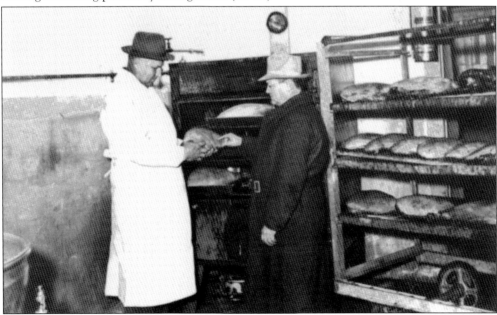

INSPECTING HAMS. It's hard to believe that it has been less than 100 years since meat inspection was federally mandated. Under the Theodore Roosevelt administration, the Meat Inspection Act of 1906 called for reforms to the process of cattle, sheep, horses, swine, and goats destined for human consumption. Cleanliness standards were established for slaughterhouses and processing plants in Smithfield and across the country. (IOW.)

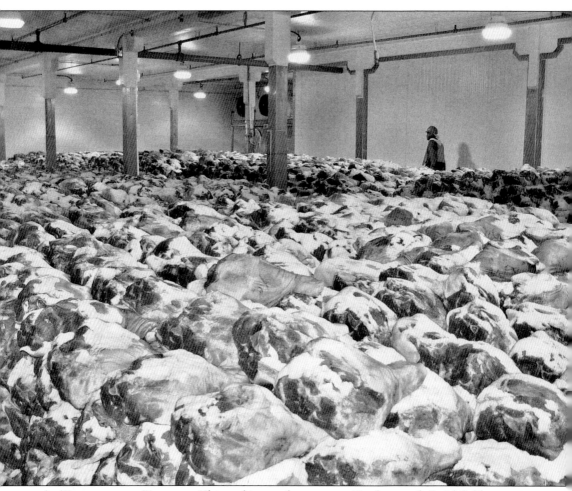

A Ham-ongous Display. This refrigerated room at Gwaltney of Smithfield contains thousands of salted hams going through the curing method and awaiting smoking and then aging. When a fresh, or green, ham is brought in, it is rubbed with a mixture of salt and sodium nitrate by workers called powderers. Depending on the cure master and the type of ham being crafted, additional spices and/or sugar may be added, not necessarily for their preservative qualities, but rather for flavor. The meat sits in the cool room, kept at or below 40° Farenheit, giving time for the salt to seep in. As the curing mixture penetrates, juices are drawn out. The curing ham will sit generally for one and a half days per pound. It will be washed to rid the surface of the salt, placed in a net bag, and readied for smoking. Beforehand, country-style hams are traditionally rubbed with black pepper; some are also rubbed with molasses or brown sugar. Aromatic hardwood is used in the smoking, and the hams hang to age a minimum of six months. (PEH.)

94

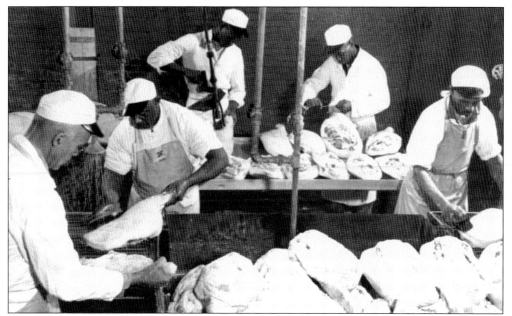

SALT BATH TO WATER BATH. A salt bath is necessary to properly cure a country ham, as shown in this c. 1950 V.W. Joyner & Co. photo. The end result is a characteristically salty flavor, accented by smokiness and pungency from aging. Saltiness can be reduced by soaking ham prior to cooking it, anywhere from 24 to 48 hours. After the ham is cooked, if it is still too salty, it can be soaked for a second, shorter time, and placed back in the oven to reheat. The salty taste of cured ham slices can be further reduced if they are fried in a skillet that contains about a quarter inch of water. Follow guidelines provided with hams regarding soaking and cooking. (IOW.)

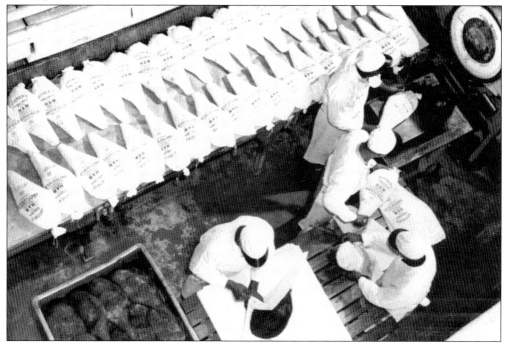

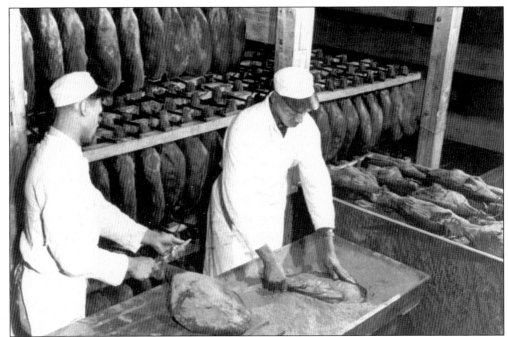

TIME-PROVEN METHOD. The men in this 1950 photo are peppering and hanging hams at V.W. Joyner & Co. Methods vary, but a period piece from Joyner said the following: "After curing for 40 days, the hams are washed, then air-dried for 14 days before being smoked over oak or hickory for two weeks. Finally the hams are rolled in pepper and hung in aging rooms for at least six months." (IOW.)

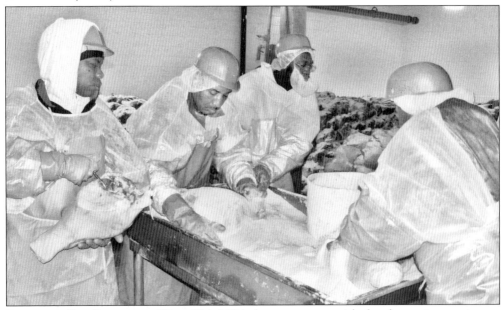

DONE THE OLD-FASHIONED WAY. This 2004 photo compares with the above vintage picture, showing that country hams are still cured the same way. This picture is of powderers, workers in a large refrigerated room at Gwaltney who run fresh, or green, ham with a mixture of salt and sodium nitrite, which prepares the cut for smoking and then aging. (PEH.)

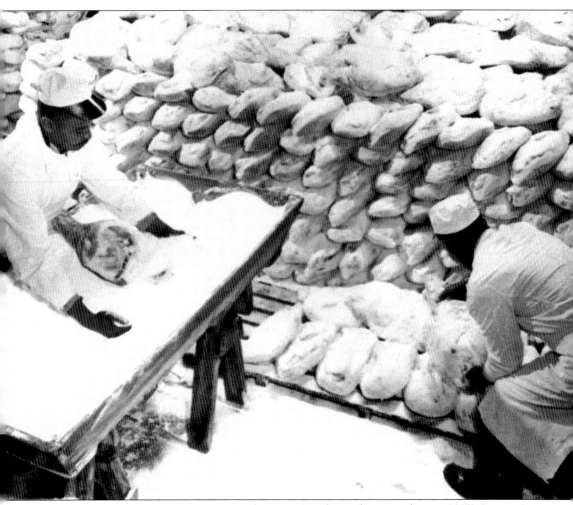

MEN SALTING AND STACKING HAMS. This *c.* 1950s photo shows workers at V.W. Joyner & Co. salting and stacking hams. At the time, there were strict guidelines before these porcine parcels could wear the title of Smithfield ham. In 1926, the Virginia General Assembly passed a law saying that genuine Smithfield hams, sides, shoulders, and jowls could only be called such if the cuts came from the carcasses of peanut-fed hogs raised in the Peanut Belt of Virginia or North Carolina. Furthermore, they had to be cured, treated, smoked, and processed in the town of limits of Smithfield. This act was redefined in 1966, since most hogs were no longer (and none now are) peanut fed. But the fine remains the same: the penalty for violation is not less than $25 or more than $300. The act is in fact a type of DOC, or denomination of controlled origin, such as found in the wine industry. (IOE.)

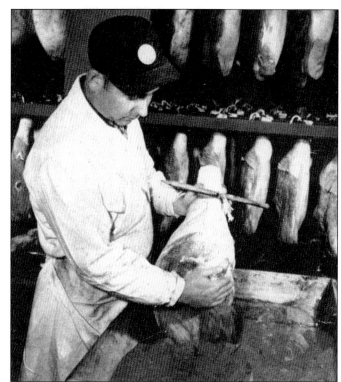

SPICE GUY. The man in this *c.* 1950 photo at V.W. Joyner & Co. is peppering a ham just before the smoking and aging process. Equalization occurs during smoking; after curing, the ham should be stored in a 50–60° Farenheit environment for at least 14 days to permit the cure to be distributed evenly throughout. The ham shrinks at this time. Smoking is usually introduced now to speed drying and to add flavor. (IOW.)

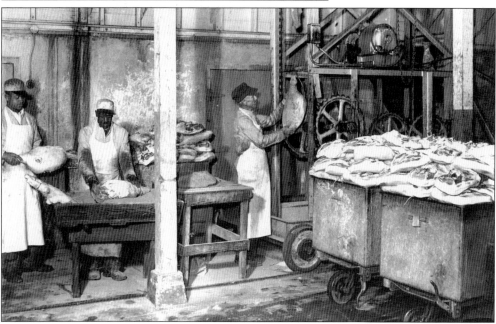

KEEPS AWAY THE FOUR-LEGGED INVADERS. In this 1950s photo at Smithfield Ham and Products Company, workers are peppering and hanging hams. Gwaltney of Smithfield's director of sales Larry Santure said coating the ham with pepper before it was hung to age was learned early on by colonists as a way to "keep four legged invaders away." It seems bears, dogs, and the like don't care for extra spice. (IOW.)

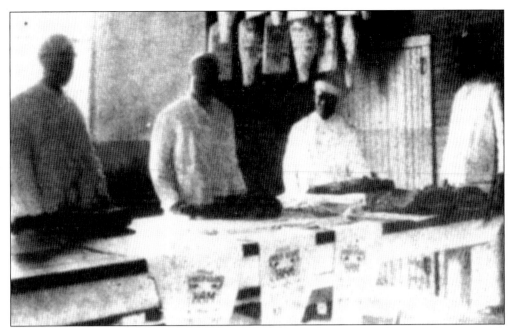

WRAP IT UP. Smithfield Ham and Products Company workers wrap up hams in the company's original plant, *c.* 1925. Wrapping up and shipping off ham has a long tradition: Virginia ham is one of the first agricultural products ever exported from the New World. In his 1749–1760 diary, "Travels through the Middle Settlements of North America," Rev. Andrew Burnaby writes that Virginia pork was superior in flavor to any in the world. (IOW.)

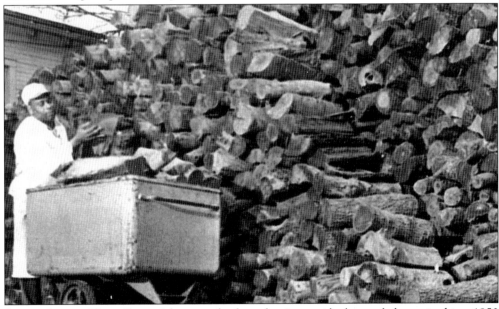

SMOKE GETS IN YOUR EYES. A large stack of wood waits outside the smokehouse in this *c.* 1950 photo at V.W. Joyner & Co. During smoking, the cured ham is hung for a period of time and absorbs the essence from smoldering fires, adding flavor and color to the ham. It also dry cures the meat, retarding rancidity. Typically, aromatic hardwoods such as hickory, applewood, or oak are used. (IOW.)

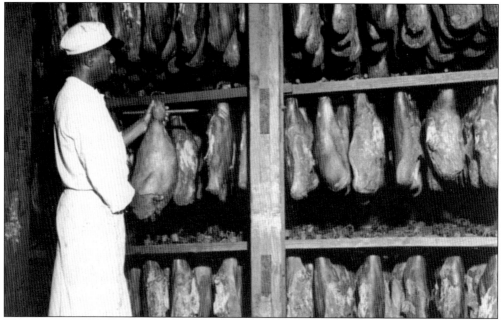

THE SULTANS OF SWINE. These photos show how little the process of curing country hams has changed. The above *c.* 1960 photo, taken at V.W. Joyner & Co., shows hams hung to be smoked. The bottom picture, taken in 2004, is of the Gwaltney of Smithfield (Smithfield Foods) smokehouse. Hams smoke for about 11 days, at which time they lose between 20 and 25 percent of their original weight; a ham that was originally hung weighing 25 pounds will come out weighing about 15 pounds. As they dry, the netting around them becomes more taught. The hams will then age appropriately. Another aspect of Smithfield hams can be seen here; typically they are cut at a different, longer bias, as shown in the length of the pork. (IOW; PEH.)

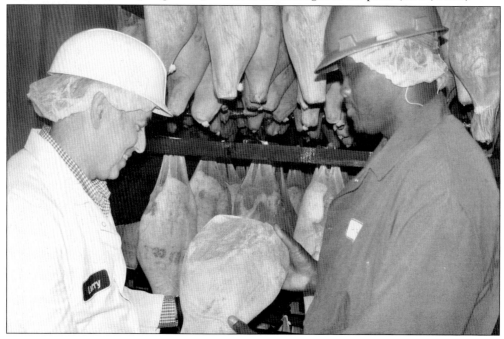

HUNG OUT TO AGE. Not all country hams are smoked. The ham in this 1907 photo is being hung to age on a post in the cure master's yard. Aging is a critical part of making country ham; it is where the flavor of the pork develops, as with a fine wine or cheese. In aging, ham often picks up a coat of harmless mold, perfectly normal (as in bleu cheese) and flavor-enhancing. (IOW.)

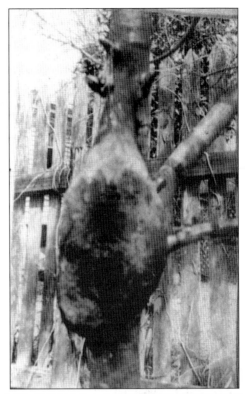

HAMS HANGING OUT. Although methods vary, generally once a ham is cured, it is aged in a room with moderate temperature and humidity for a minimum of 25 days, although around 120 days produces the best results. For smoking, a ham is hung in a smokehouse and allowed to absorb smoke from smoldering fires of hickory, apple, maple, or other hardwood. This c. 1950 photo of the Gwaltney smokehouse shows the method. (IOW.)

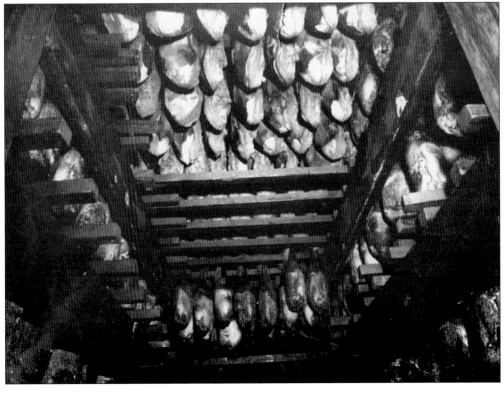

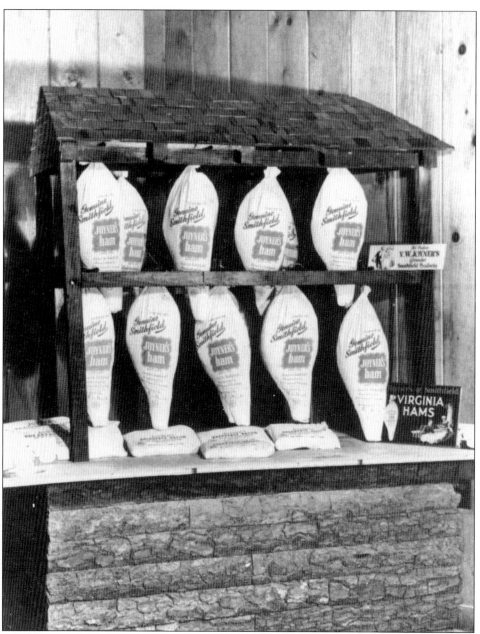

THE OLD CURING SHED. This 1957 display from V.W. Joyner & Co. shows a replica of a curing shed, complete with packaged hams hanging. After smoking, a ham is hung to age, much like the aging involved with fine wine or cheese. It is during this period that the full flavor of the ham is developed. The time allotted for aging varies; generally 45–180 days between 75–95° Farenheit. Typically, Virginia hams are long cured, which means that they are aged for six months or longer. Some hams are aged longer, up to 18 months, a process that adds even more complexity and nuance to the taste. Once a ham has been cured and aged, it is best to hang it in a cool, dry place until ready for use. The ham shouldn't lay flat on a shelf because it will absorb moisture and, potentially, flavors. Likewise, when hung, it should not touch the wall or other hams. Stored this way, a ham needs no refrigeration. (IOW.)

Five

THE HAM-ONGOUS BISCUIT

When your town is home to the world's largest pork processor, what do you do to celebrate?

Make the world's largest ham biscuit, of course.

The year 2002 was the 250th anniversary for Smithfield; the town was incorporated in 1752. Because so many people around the world automatically think "ham" when they hear the name "Smithfield," the pork product was prominently displayed.

The anniversary/event took place September 26–29, 2002. Of note was the construction of the World's Largest Ham Biscuit. How large, you ask? It was 8 feet in width, 14 inches tall, and weighed 2,200 pounds total—500 pounds of which were genuine Smithfield ham. On March 21, 2003, the folks at Guinness World Records officially named the creation the World's Largest Ham Biscuit.

Other fun things happened that weekend too: an appearance by baseball great Cal Ripken Jr., concerts, a parade of sails on the Pagan River, and the burying of a time capsule.

But it was the big biscuit that drew folks from all over and still enchants visitors to the Isle of Wight County Museum, where they can see video of the biscuit's construction in the museum's ham gallery.

We may not be around for the 500th anniversary and what may be planned then, but there are some ways to ham it up in Smithfield each year: the Olden Days, Pig Jig on the Pagan, and the Isle of Wight County Fair are a few.

BAKING HISTORY. These are the original plans for the World's Largest Ham Biscuit, a project that included work by engineers, ham specialists, and chefs. Together, the engineering department at Smithfield Foods and the Norfolk firm Machinery Specialists built the special equipment needed to pull off the job and bake and make history. (TLE.)

IT'S A PIECE OF CAKE. Or maybe it's a piece of biscuit. Jimmy Horton of the Smithfield Foods engineering department discusses the task ahead with Betty Thomas of the Smithfield Inn. It took a lot of special equipment to craft the big biscuit. Sheet-metal fabricators created a special ten-foot-square oven with glass windows for viewing. From the engineering department came a giant (eight-foot, six-inch) aluminum baking pan and a Teflon-coated cutting blade. A borrowed forklift finished the tools list. To put it all together, Smithfield Foods built a temporary 90-foot outdoor kitchen in front of its corporate headquarters. Eight persons, including Jimmy and Betty, worked on the Biscuit Team for more than a year before its completion. The biscuit was large enough to be cut into 1,752 slices (to parallel Smithfield's founding in the year 1752), but it was later decided to keep it whole and instead offer 1,752 individual ham biscuits to onlookers. (TLE.)

ROLL IT OVER, ROLL IT OVER. Chef Michael Toepper tosses in the pan biscuit dough that will help create the World's Largest Ham Biscuit. Toepper was executive chef at the Smithfield Inn at the time. Because there was no mixing bowl big enough, the dough had to be created in five batches. (TLE.)

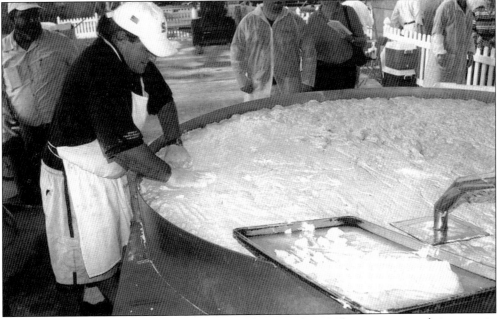

I'LL CRUMBLE FOR YA. The big biscuit, baked for more than 14 hours in a special giant pan in a 10-foot-square oven, almost gave Chef Michael Toepper trouble when he sliced it: the top wanted to crumble to bits. But it stayed whole, and by reports of the folks who sampled it, tasted pretty good too. (TLE.)

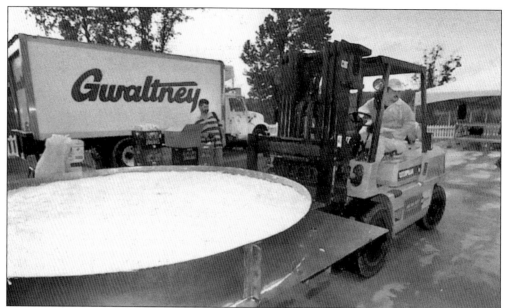

NO, I SAID FORK, NOT FORKLIFT. More than 1,000 pounds of flour and almost 1,000 pounds of other ingredients made the World's Largest Ham Biscuit a little heavy for tote to the oven, so a crane was implemented. It was quite an ordeal. Originally, the Biscuit Team wanted to be able to mix, bake, stuff, and slice its creation all on the same day of the event. However, in trial runs, they found out that the quick bread wasn't so quick—it took more than 14 hours to bake. The rest of the process was pretty time consuming, too: there were more than two hours of mixing time and more than an hour just to slice it. So, crafted in five batches at a time, the dough filled the special biscuit pan the day before the event. The next morning, the aroma of the baking biscuit wafted across town. When it came out, it still had to be cooled; slicing didn't start until after noon. But by 2:23 p.m., the biscuit was stuffed, the top placed back on, and the rest was history. (TLE.)

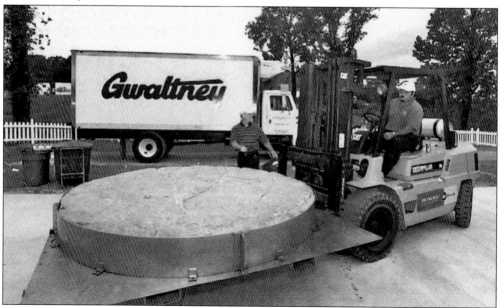

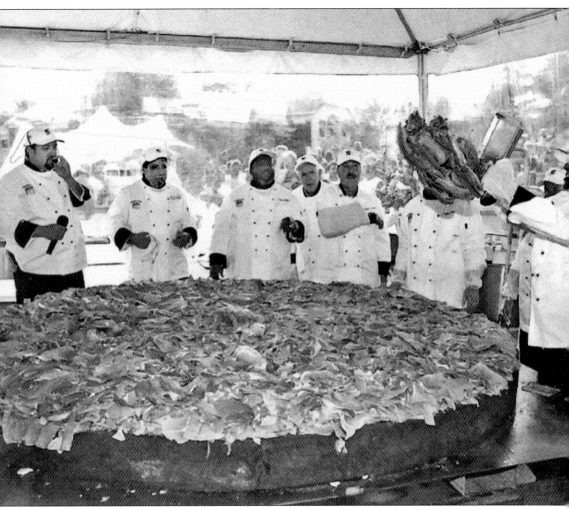

THROWING CAUTION TO THE WIND. Or is that ham being thrown by Smithfield mayor James B. Chapman? It took 500 pounds of ham to fill the insides of the fluffy eight-foot biscuit. And although that ham was used for show only, an equal amount went to help out some good causes. Gwaltney of Smithfield donated 500 pounds of ham to food pantries, shelters, and assisted living centers across Isle of Wight County, the city of Suffolk, Virginia, and the town of Franklin, Virginia. The ham giveaway was the company's way of sharing the anniversary celebration with folks who were otherwise unable to attend, said Timothy A. Seeley, president of Gwaltney of Smithfield. Folks who did show up to see the big biscuit were rewarded, too: the Smithfield Inn made 1,752 ham biscuits to hand out to the hungry crowds. (TLE.)

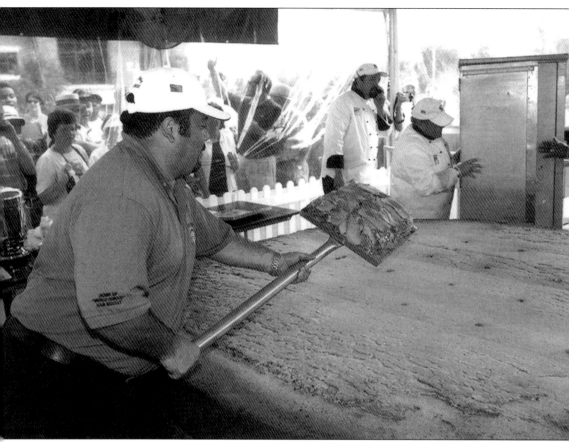

COOKING UP SOME CONTROVERSY. The biscuit almost crumbled when the tiny Kentucky town of Cadiz heard about the undertaking in Smithfield. Folks there said that for every year since 1986, the local Future Farmers of America and organizers of the Trigg County Ham Festival always made a ten-foot, six-inch ham biscuit that was sliced into pieces and sold as a fundraiser. But their biscuit just topped out at 400 pounds; the Smithfield biscuit weighed more than a ton. "Please do not confuse biscuit and ham with Ham Biscuit," said Betty Thomas of the Smithfield Inn. "The two are completely different creations." Thomas said the Smithfield biscuit was a true biscuit—whole, round, and fluffy. The folks in Cadiz said their biscuit was thin and flat, more like a big cookie. In the end, and after five months of research, the documentation Smithfield sent to Guinness World Records for their biscuit was selected for the honor.

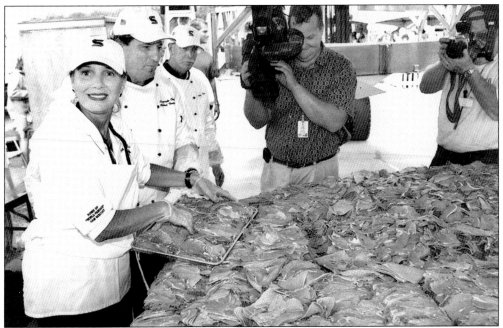

SUPER SIZE ME, PLEASE. That might have been what Betty Thomas was thinking when the idea for the World's Largest Ham Biscuit came up. Betty, who was marketing director for the Smithfield Inn at the time of the celebration, explains it this way: "The idea of cooking the world's largest ham biscuit originated when *USA Today* newspaper picked 50 plates of food in the United States, one plate of food from each state, in 2000. The Smithfield Inn won this award for the ham biscuit. To celebrate the 250th year old birthday for [the town] . . . [we] formed the Ham Biscuit Team . . . [a] team of engineers, ham specialists [and] . . . chefs to build the largest ham biscuit in the world." Betty said the team worked, designed, and implemented plans for more than a year to achieve its goal. Here Betty helps load the big biscuit up with some genuine Smithfield ham. (TLE.)

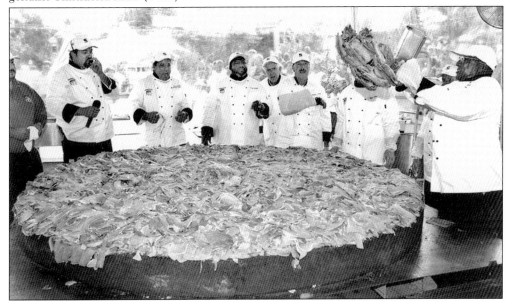

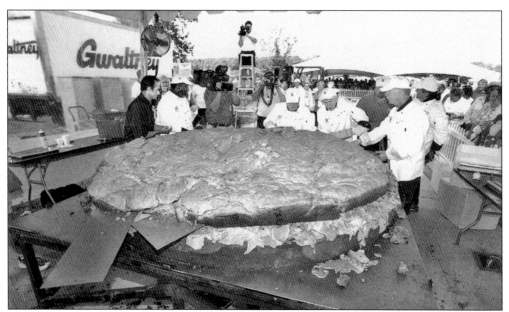

THE NOTORIOUS B.I.G. BISCUIT. The World's Largest Ham Biscuit was a perfect way to celebrate Smithfield's 250th anniversary; it is literally an event for the history books. Of the event, Smithfield Foods chairman and chief executive officer Joseph W. Luter III said, "The Smithfield community and our company share the same name and the same tradition of quality. When you say 'Smithfield' around the world, the word 'Ham' is the first thought that comes to mind. We are proud that our company has had the opportunity to be a significant part of the Smithfield ham tradition since our inception in 1924. While you are here, stop by the Smithfield Inn to enjoy the world famous 'Smithfield Ham Biscuit,' selected by *USA Today* as the top food item for the state of Virginia. No trip to Smithfield is complete without this delicacy." (TLE.)

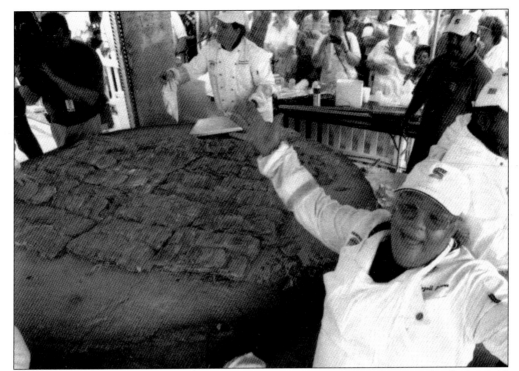

FINALLY! That seems to be the sentiment of Mozell Brown as the big biscuit is finished at 2:23 p.m. on September 28, 2002. Mozell, who has been making ham biscuits at the Smithfield Inn for the past four decades, was a special consultant in formulating and preparing the biscuit mix. (TLE.)

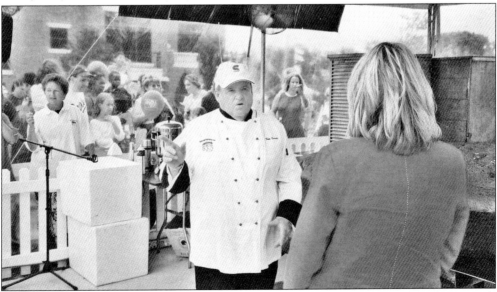

RESEARCHED AND DEVELOPED. Biscuit Team member Tom Evans discusses the big biscuit with onlookers following its completion. Tom works in research and development for Gwaltney of Smithfield, coming up with delicious new ways to enjoy ham and pork products. It took lots of talented people at Smithfield Foods to complete the World's Largest Ham Biscuit. (TLE.)

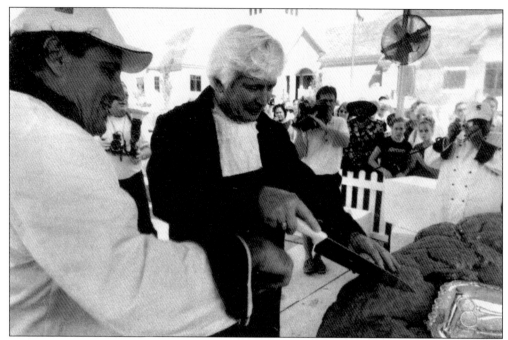

FATHER OF THE COUNTRY MEETS MOTHER OF ALL BISCUITS. This George Washington interpreter was invited to slice into the World's Largest Ham Biscuit at the ceremony on September 28. Although the biscuit was not to be eaten, a portion of it had to be sampled to satisfy the folks at Guinness World Records that it was indeed edible. (TLE.)

IT TAKES A VILLAGE. On the Biscuit Team were, from left to right, (front row) Jimmy Horton from Smithfield Foods Engineering, Tony Newby of Smithfield Foods Corporate Office, Betty Thomas of the Smithfield Inn, Chef Michael Toepper of the Smithfield Inn, Tom Evans of Gwaltney of Smithfield, and Doug Ellis of Gwaltney of Smithfield; (back row) Forrest Scott of the Smithfield Inn, Roger Case of Machinery Specialists, and Jeff Davis of Smithfield Foods. (TLE.)

LOOK, BUT DON'T EAT. The World's Largest Ham Biscuit was displayed under an acrylic case for two days after assembly, but, like all good things, it had to come to an end. "You just can't preserve a biscuit," said Betty Thomas, who was marketing director for the Smithfield Inn at the time of the biscuit brouhaha. "It just goes bad. But it did what we wanted it to do. It fed the spirits of everyone. It put smiles on all of their faces." Betty said originally the Biscuit Team would have liked to have found a way to keep the biscuit for long-term display, but it was apparent it wouldn't work. But all is not forgotten: part of the ham exhibit at the Isle of Wight County Museum features a display all about the big biscuit. The display includes one of the Biscuit Team member's chef jacket, the proclamation from Guinness World Records, a film showing clips of the assembly, and even a portion of the biscuit ring mold. (TLE.)

BISCUIT BATTER, UP. Former Baltimore Oriole Cal Ripken Jr. was grand marshal for the History of Smithfield: Parade on Main Street, September 28, 2002, during the anniversary celebrations. Ripken played professional baseball for 21 years and set the record for the most consecutive games played in the majors. He retired in 2001. Among his other accomplishments are: American League Rookie of the Year in 1982 and All-Star Game Most Valuable Player in 2001. Ripken's tie to Smithfield is through Esskay meats (hot dogs, etc.). Esskay is a major brand of Gwaltney of Smithfield, which is a division of Smithfield Foods. Ripken has been a spokesperson for Esskay, and the company is one of his corporate sponsors. (TLE.)

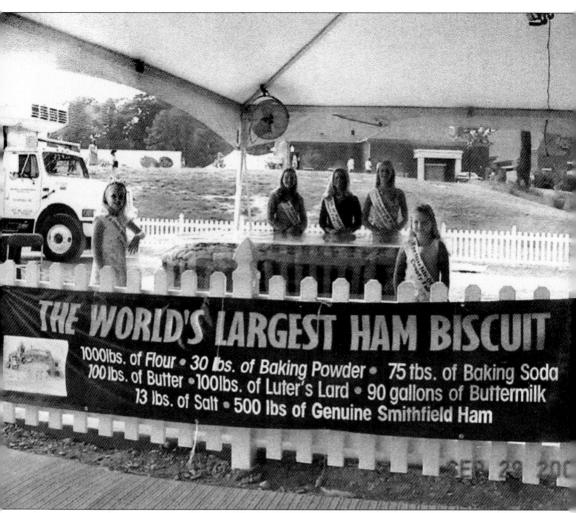

ENOUGH TO FEED A TOWN. The World's Largest Ham Biscuit was indeed big enough to feed a small town: creators calculated the yield would be 1,752 servings (to commemorate the town of Smithfield's founding year of 1752). Do you want to re-create the biscuit at home? The *Antiques Emporium of Smithfield Kitchen Classics* cookbook has the recipe on page 70. The ingredients include 1,000 pounds of flour, 30 pounds of baking powder, 75 pounds of baking soda, 100 pounds of Luter's Lard, 90 gallons of buttermilk, 13 pounds of salt, and 500 pounds of genuine Smithfield ham. By the way, you'll also need an eight-foot oven, a forklift, and a Teflon-coated knife some nine feet across. Good news: ham biscuits freeze beautifully. (TLE.)

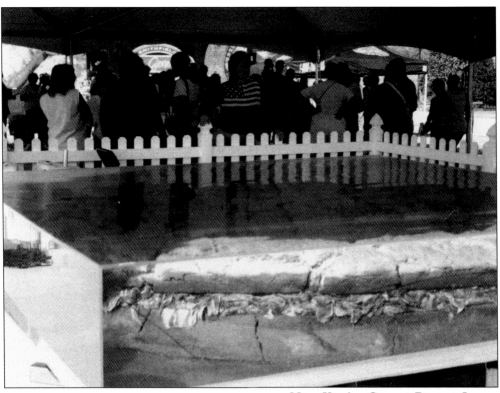

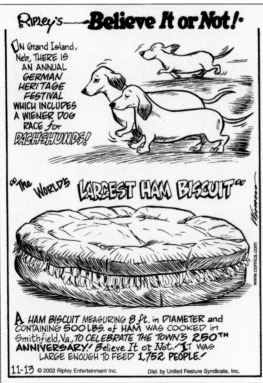

NOW YOU'VE GOT TO BELIEVE IT.
Smithfield again made the panels of Ripley's "Believe It or Not" cartoon in November 2002 with the World's Largest Ham Biscuit. The 'toon, which appears daily in 180 newspapers in 42 countries, has three times before promoted the Ham Capital of the World with mention of P.D. Gwaltney Jr.'s pet ham. This time, however, the biscuit took top billing. The Ripley's report reads: "A ham biscuit measuring 8 feet in diameter and containing 500 pounds of ham was cooked in Smithfield, Va. to celebrate the town's 250th anniversary! Believe It or Not! It was large enough to feed 1,752 people." Also included was an artist's rendering of the big biscuit, a hallmark of the column. The feature, which was created in 1918 by Robert Ripley, a sports cartoonist for a New York newspaper, showcases 24 items a week for inclusion in the cartoon. (IOW.)

Six

BRINGING HOME
THE BACON

Once one samples the sinfully sublime Smithfield variety, it is hard to go back to the gelatinous, flavorless pork product that unceremoniously pops out of a tin can and calls itself "ham." Fortunately, for folks who don't live in southeastern Virginia, there are several ways to enjoy the unique flavors of Smithfield without an actual visit (although that is always an option.) Good news for the culinary challenged—if you don't know your ham from a hock, there are convenient packs of ham, precooked and available in half-hams or in slices. And if you don't even want to fire up the microwave, a trip to Smithfield will yield several top-notch restaurants that feature the delightful delicacy on the menu.

Once one has fed the stomach, one can feed the mind; there are numerous physical and virtual ways to learn more about the rich lore of the ham industry, one of the tastiest footnotes in American history, through interactive exhibits, books, and other means.

This chapter examines ways you can explore ham heritage and enjoy ham products, as well as sample a slice of the quaint town of Smithfield. Bon appétit.

SLICE IT, AND THEY WILL COME. "The market has moved away from whole hams to portions," says Smithfield Foods chairman and chief executive officer Joseph W. Luter III. "People don't stay at home and cook as much." But who can wait until the holidays to enjoy the sultry, salty taste of Smithfield ham? Items like half-hams and hams slices are readily available year-round in many grocery stores and by mail order. (PEH.)

A SMITHFIELD SNACK. Smitty Pig, the FPV (First Pig of Virginia), loved living high-on-the-hog, wearing a top hat and tails, sipping top-shelf libations, and munching on canapés made from Amber Brand Deviled Smithfield Ham (made by mixing the spread with cream cheese and topping with a dab of pepper jelly). A product of James C. Sprigg Jr.'s Smithfield Ham and Products Corporation (now part of Smithfield Foods), deviled Smithfield ham became popular in the 1930s. At coffee shop and drug store lunch counters, a sandwich made of the premium spread could sell for more than a typical ham sandwich. Later, the virtues of the tasty spread were sung in a nationwide $100,000 advertising campaign in the 1940s. It was a true American culinary classic (awarded the Seal of Culinary Merit from the American Culinary Federation), used for everything from an omelet filler to stuffing tomatoes or green peppers. The spread and other such products are still available today from *The Smithfield Collection* (mail order) or to be picked up at the Genuine Smithfield Ham Shoppe. (IOW.)

VIRGINIA HAM SANDWICH

Spread two pieces of toast with a good Thousand Island dressing. On one piece place a tender leaf of lettuce, then two slices of Virginia ham, cut thin. Close sandwich and garnish with spiced fruit.

SUPREME OF CHICKEN WITH VIRGINIA HAM

Place a thin slice of Virginia ham on toast. On the ham place a fried breast of a 2-pound to 3-pound chicken. Top with two or three fresh mushroom caps previously cooked in the ham drippings. Pour all the drippings over the chicken breast; sprinkle with parsley. Serve in round au gratin dish.

VIRGINIA HAM HOLLYWOOD

Alternate slices of cold Virginia ham and chicken. Serve with an orange basket filled with fresh fruit salad. Garnish with a julienne of carrots and celery marinated in French dressing and placed on watercress.

YOU'VE COOKED IT, NOW WHAT? What to do with a cooked Smithfield ham? Eat it, of course. The above somewhat campy illustration comes from a *c.* 1945 brochure promoting Smithfield ham and some of the ways to enjoy it. Recipes include a classic Virginia Ham Sandwich (although most Southerners eat theirs sans Thousand Island dressing or with mayonnaise instead), Supreme of Chicken with Virginia Ham, and Virginia Ham Hollywood. Missing from the illustration is the classic compliment to country ham: red eye gravy. Here is a quick-and-easy recipe:

> Brown both sides of eight country ham slices in two tablespoons oil in a large skillet; remove ham; add three-fourths cup strong black coffee to drippings; sprinkle with one teaspoon sugar and stir; cover and simmer for five minutes; pour over ham slices, grits, sliced biscuits, and other such Southern delicacies.

Smithfield ham is also delicious served simply with one thin slice folded in two and stuffed in a hot, buttermilk biscuit or a heated brown-and-serve roll. (IOW.)

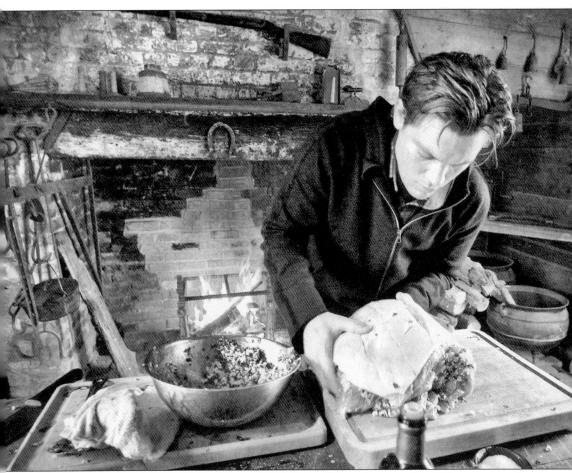

HAUTE HOG CUISINE. There is more than one way to cook a Smithfield ham, knows Food Network television personality Chef Tyler Florence. Tyler visited Smithfield in December 2003 to film an episode of *Tyler's Ultimate* to talk to folks about the local cuisine. During his visit, he visited the Smithfield Inn and the smokehouse at Dee Dee and Tommy Darden's farm, and he cooked a fresh ham stuffed with Tuscan bread, fresh spinach, olives, pine nuts, golden raisins, and a variety of spices in the plantation kitchen at Windsor Castle. Of country hams, he said, "This is one of the oldest processes in authentic American cooking" and reckoned it as "American prosciutto." Tyler also said the smoky aroma reminded him of his childhood in South Carolina. "It smells like black pepper and country ham and red eye gravy and it makes my mouth water." Tyler has said he likes to put a new twist on old favorites and demonstrated in this television show that country ham isn't just for biscuits anymore. (John H. Sheally II/*The Virginian-Pilot*.)

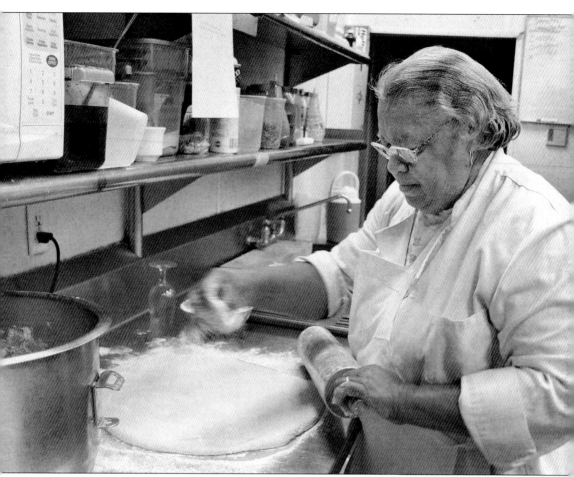

MOZELL BROWN MAKES HER FAMOUS SMITHFIELD INN HAM BISCUITS. For more than four decades, Mozell Brown has been wowing diners at the Smithfield Inn with her country-inspired cuisine, including her famous Smithfield ham biscuit. Making Virginia-style ham biscuits has been a part of her life, having learned the secret family recipe from her late mother, Nannie C. Ricks. Mozell is a true artist with her technique, mixing wet and dry ingredients, rolling out the dough, and shaping perfectly round biscuits that, when baked, rise light and fluffy and make the perfect foil to sweet, salty, wafer-thin slices of Smithfield ham. Her ham biscuits are so good, in fact, that in 2000, in a state-by-state food sampling survey, *USA Today* named the inn's Smithfield ham biscuit plate as the top food item from Virginia. Alas, no one knows the secret to the biscuits except Mozell, but if you come to the Smithfield Inn, she'll make some for you, too. The inn is located at 112 Main Street, and the phone number is 757-357-1752. (PEH.)

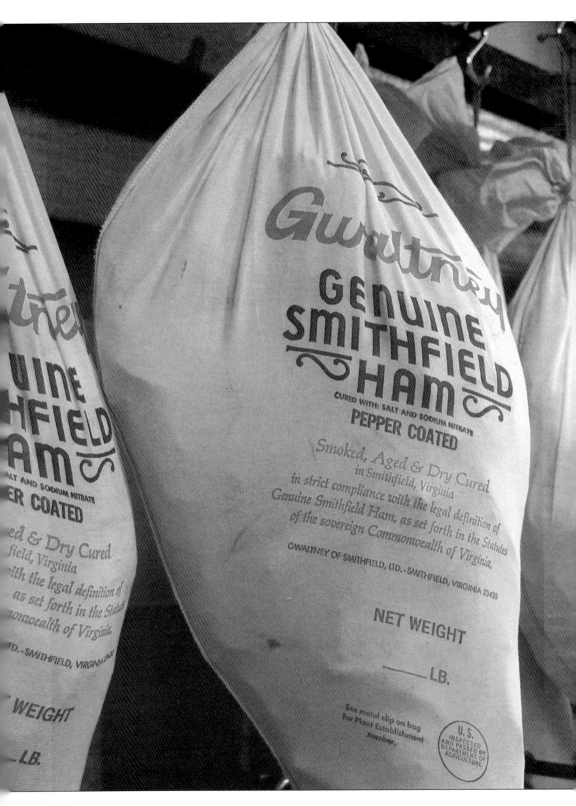

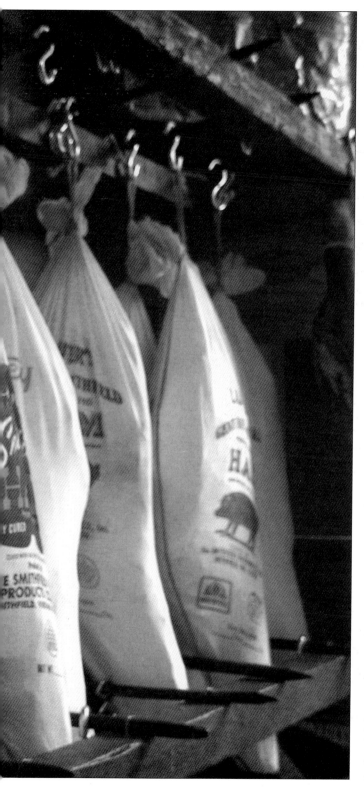

THE GENUINE SMITHFIELD
HAM SHOPPE. A plethora of
pork hangs in the Genuine
Smithfield Ham Shoppe in
downtown Smithfield. A
wide assortment of country
ham labels are available,
including those pictured here:
Gwaltney Genuine
Smithfield Ham, Peanut City
Country Ham, Joyner's Red
Eye Country Ham, and
Luter's Genuine Smithfield
Ham. The shop also sells
half-ham, ham slices, and
other items like gourmet
peanuts and other specialties,
Virginia wine, pig
collectibles, and more. It also
sells the famed Charles
Henry Gray ham. For those
who can't make it to
Smithfield, genuine
Smithfield ham and related
products can be shipped to all
50 states. The quaint shop's
small, country store feel, as
well as the friendly and
knowledgeable staff, make a
stop by here a necessity
when in town. The shop is
located at 224 Main Street,
and the phone number is
800-628-2242. (PEH.)

ISLE OF WIGHT COUNTY MUSEUM. Housed in the former Bank of Smithfield building, the museum features a gallery devoted to the history of Smithfield's meat packing industry. On display is P.D. Gwaltney's pet ham/world's oldest ham, a video showing the construction of the world's largest ham biscuit, and other historical ham memorabilia. Part of the collection includes items from Gwaltney, Luter, Joyner, and Smithfield Packing. The museum, owned by the county, affords residents and visitors a historical retrospective of Isle of Wight and Smithfield; all aspects of local history are featured in the museum's seven galleries. A highlight is an authentic reproduction of an old-fashioned general store. The war memorial gallery features many artifacts, including the gilded wood eagle wrenched from the USS *Smith-Briggs* following the Civil War Battle of Smithfield. The museum's main gallery is reserved for changing exhibits. There is also a gift shop with various items for sale, including antique reproductions, hand-crafted items, jewelry, local souvenirs, collectibles, and a wide selection of books. The museum is located at 103 Main Street. The phone number is 757-357-7459. (PEH.)

How to Contact

HAM HERITAGE
Isle of Wight County Museum
Features a display on the ham industry and other exhibits on local history.
103 Main Street, Smithfield, VA, 23431
757-357-7459

HAM PRODUCTS
The Genuine Smithfield Ham Shoppe
224 Main Street, Smithfield, VA, 23430
800-628-2242; 800-292-2773; 800-926-8448
www.smithfieldhams.com; www.smithfieldcollection.com

Virginia Department of Agriculture and Consumer Services
This website offers links to a number of Virginia-made products, including ham from other purveyors such as S. Wallace Edwards & Sons of Surry, VA.
www.vdacs.state.va.us/consumer.index.html

MISCELLANEOUS
Smithfield & Isle of Wight Convention & Visitors Bureau
The website provides links to attractions, lodging, dining, and special events like Olden Days, Pig Jig on the Pagan, and the Isle of Wight County Fair.
335 Main Street, Smithfield, VA, 23430
757-357-5182; 800-365-9339
www.smithfield-virginia.com

Smithfield Historic District Business Association
Comprehensive information on businesses, including lodging and dining.
www.shopsmithfield.com

The Smithfield Inn
Historic 1752 inn and restaurant, featuring award-winning food, including ham biscuits.
112 Main Street, Smithfield, VA, 23430
757-357-1752
www.smithfieldinn.com

Smithfield Station Restaurant
Restaurant, lodging (one guestroom is in a lighthouse), and marina. Menu items include Smithfield ham and Lean Generation pork products.
415 South Church Street, Smithfield, VA, 23430
757-357-7700
www.smithfieldstation.com

Smithfield Gourmet Bakery and Café
Homemade bread and sweets and a menu with many unique uses of Smithfield ham.
218 Main Street, Smithfield, VA, 23430
757-357-0045

Ham 101

PREPARATION:

–If you have a fully cooked ham, no further preparation is necessary; just slice and serve.

–If your ham is uncooked, soak before cooking since these hams are dry-cured. Soak Smithfield or country hams 24 hours or longer. Change water every four hours. Longer soaking (up to 36 hours) results in a less-salty ham.

–After soaking, wash ham thoroughly with a stiff brush to remove all pepper and mold, if present.

OVEN COOKING:

–Wrap ham in heavy-duty aluminum foil, joining edges to form a vessel with the bottom layer. Add five cups of water for a Smithfield or country ham within the foil and place in oven with a tray or pan underneath for support.

–Preheat oven to 500° Farenheit. Once oven reaches 500°, bake for 15 minutes. Turn off the oven for three hours. Then heat oven to 500° and bake another 10 minutes. Turn off oven and let ham remain for 6–8 hours; overnight is satisfactory. Important: do not open oven door until the cook cycle is complete, including the last 6–8 hours.

WATER COOKING:

–Place in large roasting pan, skin-side down, and cover with cool water.

–Bring water to 180° Farenheit, not quite simmering. Cook to 160° internal temperature, about 25 minutes per pound. Add water to keep ham covered.

–Remove ham from pan and while warm remove skin carefully without tearing the fat. Dot the surface with cloves if desired, sprinkle with brown sugar and bread crumbs, and bake for 15 minutes at 400° Farenheit, or long enough to brown nicely.

CARVING:

–To bring out the delicate flavor of the Smithfield or country ham, slice it very thin, using a very sharp, long, and narrow knife. If you have a boneless ham, just begin slicing at the small end and serve. Smoked hams are carved in a similar manner, but they may be sliced slightly thicker, if preferred.

–For bone-in hams, place ham on a flat surface, dressed side up, begin about two inches from the hock (the small end), and make the first cut straight through to the bone. Slant the knife slightly for each succeeding cut. Slice down to and partially around the bone. Decrease slant as the slices become larger. Eventually the bone formation will cause you to cut smaller slices at different angles.

SERVING:

–The flavor of a Smithfield or country ham is best served at room temperature. These hams can be served a number of ways, including sliced and served on biscuits, pan-fried and served with red-eye gravy, or used in soup or to flavor vegetable dishes.

STORING:

–Uncooked country hams may be safely stored hanging in a cool, dry area. Smithfield hams will keep up to one year, and country hams will keep for up to six months from date of manufacture.

–Cooked Smithfield ham and country ham will keep for at least six weeks under refrigeration at 40° Farenheit or below. Cooked ham may be frozen, but the bone should be removed first.

(Information adapted from the Smithfield Foods website and from the Genuine Smithfield Ham Shoppe.)

Ham Definitions

AGED HAMS–Cured and smoked hams hung to age from one to seven years.

CANNED HAM–Whole piece of meat or meat pieces pressed into a form and held with a gelatin mixture that is canned and sold.

COUNTRY-CURED–Hams dry-cured at least 70 days, then smoked over fragrant hardwoods and aged a minimum of six months. During aging, a harmless mold typically occurs on the ham surface, which is scrubbed and washed off before cooking. Most are sold uncooked, but increasingly, fully cooked hams are available. The country's most famous country-cured hams come from Virginia, Georgia, Kentucky, and Tennessee.

DRY-CURED–Also known as country hams; simply, the exterior of the meat is completely covered with salt and stored until the salt permeates the meat, thus preserving it.

FRESH HAM–Cut from the hog's hind leg that is not cured or smoked. Must be cooked before eating; done so in methods similar to other fresh pork cuts. The flavor is similar to pork roast.

HAM–Cut from a hog's upper hind, available as dry-cured (country ham), wet-cured (city ham), or as fresh ham. They may come bone-in, semi-boneless, or boneless. There are many varieties, depending on the preparation methods such as curing and smoking.

INTERNATIONAL HAM VARIETIES–Ham from around the world includes: Bayonne (air-dried, wine-cured, lightly smoked, uncooked French ham), Black Forest (air-dried, salt-cured, pine- and fir-smoked German ham), Irish (brine-cured, peat- and juniper-smoked hams from the Belfast region), jamon Serrano (dry-cured, unsmoked Spanish ham), prosciutto (dry-cured, unsmoked Italian ham), Westphalia (dry-cured, beechwood- and juniper-smoked German ham), and York (dry-cured, oak-smoked English ham). Most varieties are served sliced thin, like Smithfield ham, and are often uncooked.

PICNIC HAM–An inexpensive cut from the hog's shoulder, meaning it is not a true ham, although it is cured like one. Not as lean and tender as a true ham, it is good for soups and casseroles.

READY-TO-EAT HAM–Also known as "heat and serve" or "fully cooked ham," it is a ham that, at some part in processing, has been heated sufficiently, making it ready to eat.

SMITHFIELD HAM–A variety of Virginia ham, a name applied to country-cured hams. The hams are lean and most often smoked over hickory and applewood. The variety is considered the best of all Virginia hams and, to be called such, must be cured and processed in the Smithfield town limits. Traditionally, Smithfield hams are smoked and aged for 6–12 months or up to two years. The ham is dark, dry, salty, and rich. It is generally baked or boiled but can be eaten raw.

SUGAR-CURED HAM–Usually include cane and/or beet sugar in sufficient quantities to flavor and/or affect the appearance of the finished product. Similarly, there are honey-cured hams.

WET-CURING–Also known as brine-cured, these are often cuts from the hind leg that have been cured by soaking or injecting with water and other brining ingredients like salt, sugar, sodium nitrate, spices, and seasoning.

ABOUT THE AUTHOR. Patrick Evans-Hylton loves to ham it up on the keyboard and in the kitchen. A trained chef and food writer, Patrick also considers himself a local historian and especially loves the rich culinary history found in his adopted southeastern Virginia, like that of Smithfield ham. He is also the author of *Images of America: The Suffolk Peanut Festival*. Patrick has written for several area publications and is an editor at *Hampton Roads Magazine*, a regional city and lifestyle magazine. He also does regular food and dining reports for the "On the Town" radio show on Norfolk's WTAR 850 AM.

BIBLIOGRAPHY

Dashiell, Segar Cofer. *Smithfield: A Pictorial History*. Norfolk, VA: Donning Company, 1977.

Emery, W. Lloyd. "Smithfield, Prosperous and Unique." *Southland Magazine*. September 1910.

Everett, Marion G. and Patsy D. Barham. *A History of the Smithfield Ham Industry*. Smithfield, VA. Isle of Wight County Museum, 1993.

King, Helen Haverty. "Historical Notes on Isle of Wight County, Virginia." Isle of Wight, VA: Isle of Wight County Board of Supervisors, 1993.

"The Land of the Peanut: Louisiana Purchase Exposition Edition." Smithfield, VA: The Gwaltney-Bunkley Peanut Company, 1904.

Smithfield Foods Corporate Website. June–August 2004. <http://www.smithfieldfoods.com >

Voltz, Jeanne and Elaine J. Harvell. "The Country Ham Book." Chapel Hill, NC: University of North Carolina Press, 1999.